# RIVER TRENT

## From Sea to Source

Tony A. J. Hewitt

AMBERLEY

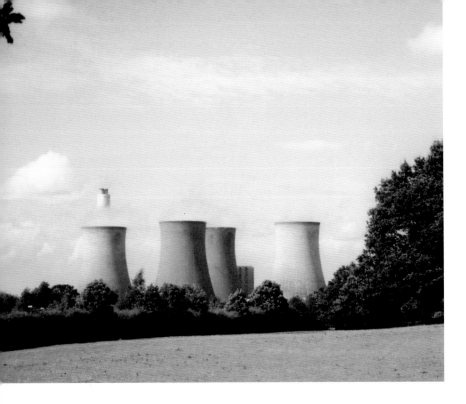

*Stanley Edward Kirkham Hewitt, 1929–2013*

*Born by the abbey*
*played at the ford;*
*A true son of the Trent*
*now at rest in the hills,*
*forever overlooking the city of his birth.*

First published 2015

Amberley Publishing
The Hill, Stroud, Gloucestershire, GL5 4EP
www.amberley-books.com

ISBN 978 1 4456 4997 9 (print)
ISBN 978 1 4456 4998 6 (ebook)

British Library Cataloguing in Publication Data.
A catalogue record for this book is available from the British Library.

Typesetting by Amberley Publishing.
Printed in the UK.

# CONTENTS

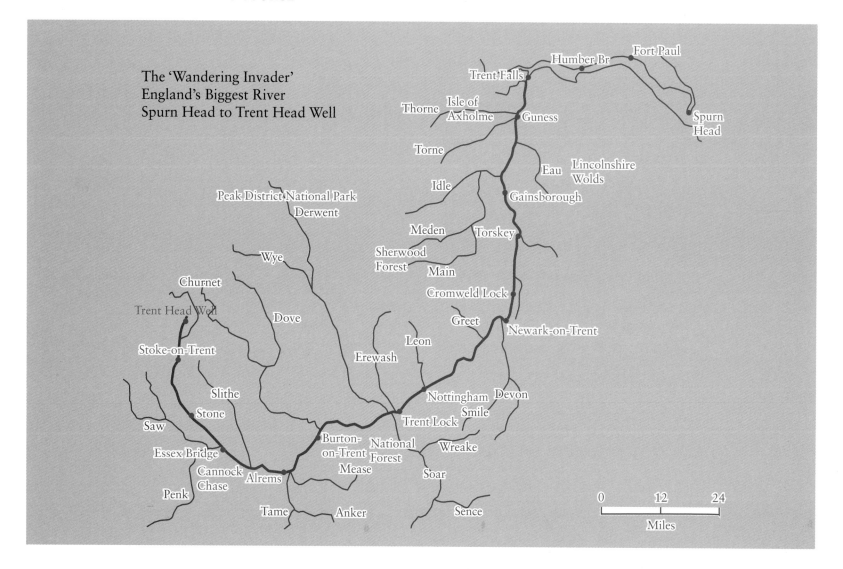

The 'Wandering Invader'
England's Biggest River
Spurn Head to Trent Head Well

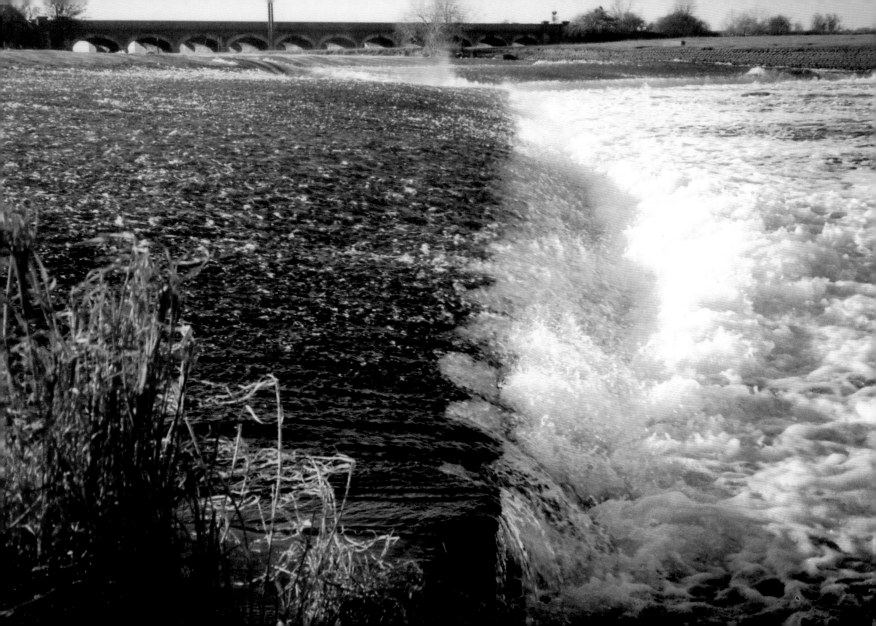

# INTRODUCTION

See how this river comes me cranking in,
And cuts me from the best of all my land,
A huge half-moon, a monstrous cantle out,
I'll have the current in this place dammed up,
And here the smug and Silver Trent shall run,
In a new channel, fair and evenly.

Powerful men have sought to tame the biggest river in England, as Shakespeare's Mortimer said to Percy as they rode off to fight Henry IV and his son, the future King Henry V.

There were many fords and ferries, but these could be treacherous due to the scouring of the riverbed in floods, making shallows disappear and the already huge volumes of water turn into violent spumes, as if the sea had burst forth. No ferrys survive today – the last was at Farndon; it occasionally gets resurrected by the landlord at the pub.

Only three new road bridges have been built in 100 years: the M180, A50 dual carriageway (the proxy M64) and the newest in Staffordshire, St Peters bridge in Burton-on-Trent – the towns second only road bridge.

Place names indicate the transitionary nature of the East of Mercias Saxon settlements: 'tons' and 'hams' are intermingled with Viking 'thorpe' and 'iths' as in Besthorpe and Stockwith or Kneith.

Bull Fort off Spurn Head, now used in SAR practices. Seen here is a helicopter winching up a 'casualty'. The fort, one of a pair guarding the mouth of the Humber, is a co-estuary of the Trent and Ouse. Humber is a name with an unknown origin, however, it is thought to be the word 'river'. Humber River is therefore a tautology!

In the distance are the Lincolnshire Wolds, which are geologically the same as the Yorkshire Wolds. The Jurassic barriers are cut through by the co-rivers but are rejoined symbolically by the Humber Bridge.

The Trent means 'wandering invader' and there are many villages along its course that can testify to severe flooding and disappearance. Why is there no settlement in the parish of Meering? Nearby Holme was moved from west bank to east in the floods of 1600; the old course is discernible for 10 miles and is called the Fleet.

Nottingham was prone to urban flooding. The last severe flood of 1947 resulted in weirs being built at Beeston and Colwick to prevent them happening again. Many of the scores of old gravel workings, still a major activity along the valley, have been used to alleviate future floods. In turn they have become wildlife havens and freshwater fishing pools. Izzak Walton noted in *The Compleat Angler*, 'Trent, so called from thirty kinds of fishes that are found in it, or for that it receiveth thirty lesser rivers'. These included his much-loved Dove, Blithe and Sow on which his dear cottage at Shallowford was located. He bequeathed this to the town of his birth, Stafford, upon his death in 1683.

Mow Cop seen from Lask Edge near Trent Well springs.

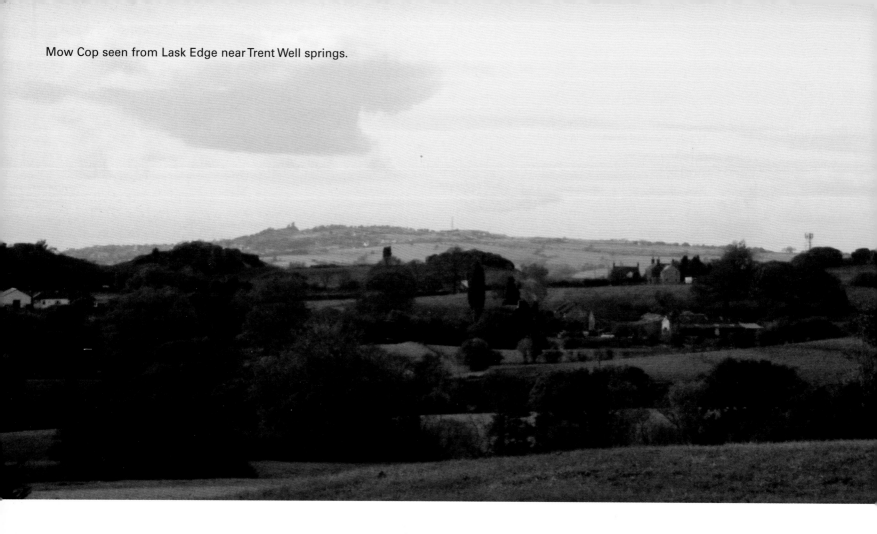

Mow Cop is the birthplace of Primitive Methodism with which
there is already a link in the Trent Valley of Epworth.

Glorious Willow, a common species along the Trent Valley, here on Biddulph Moor, 1,000 feet up.

TRENT HEAD
WELL

FOOTPATH

# TWIN ESTUARY
# SPURN HEAD TO TRENT NESS

Spurn Head is a national nature reserve of international importance that is forever shifting, especially during winter in the annual storms. The most easterly point in Yorkshire, it guards the 38 miles of the Humber.

An estuary made by two rivers, they jointly drain nearly a quarter of England. One, the Trent, rises 220 miles away and the other only begins just the other side of York!

Huge mudflats and sandbanks line Holderness' shores: Kilnsea clays, Skeffling Clays and Trinity Sands.

On Sunk Island there are very productive fields around the capital of Southern Holderness, Partington. There were many windmills to keep the land well drained, and a few remain part of the landscape today but are disused.

Sleek and silvery – morning tide going out.

The Humber Pilot and Lifeboat Station at Spurn Point, looking up the Humber. The RNLI has its only twenty-four-hour-manned station in the UK here.

Spurn Head is an island connected by an ever shifting sand bar. In 2013 Spurn Point became an island again when the winter storms severed the narrows. The sand spit has always been on the move over many centuries as evidenced by the position of the remaining two lighthouses – one beached at low tide, the other high and dry.

Spurn Point is an important pilot station as the ever shifting sandbanks are a hazard to vessels going to Goole, Selby and Gunness as well as Hull. Here too are the RNLI and coastguard stations; the SAR helicopter is based at Leconfield.

Offshore there were four lightships. The famous Spurn Head Vessel has been retained to Hull Docks and has been replaced by an automatic bouy. The other ships are called *Bull*, *Humber* and *Dolphin*.

In 1895 the new 'black and white' lighthouse replaced the earlier Smeton light. It worked until 1986, but still stands proud at the end of Spurn Head.

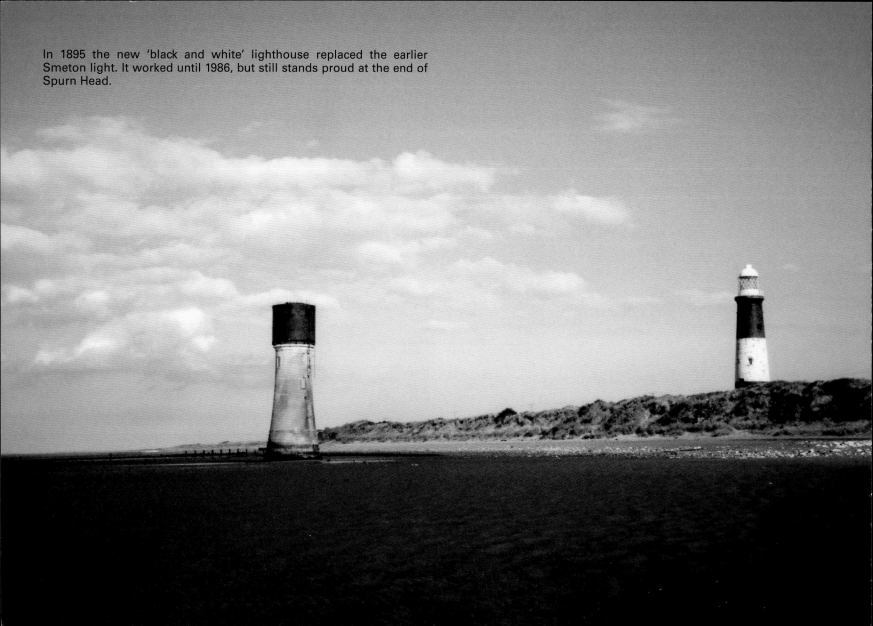

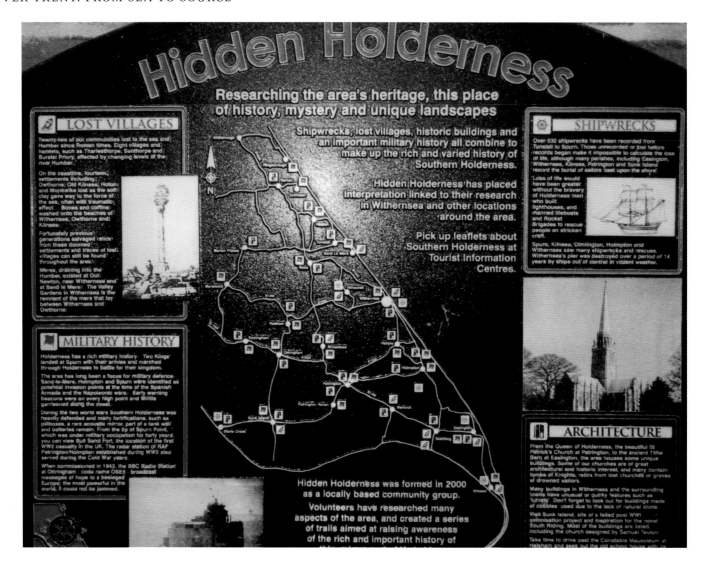

Holderness is Yorkshire's fenland. It is a peninsula of 32 miles defined by the River Hull to the west and the beginning of the Wolds. Hedon, just east of Kingston-upon-Hull is its capital.

The ever-moving coast, like that of East Anglia, has seen the loss of many settlements. From Kilnsea to Patrington Haven, the smooth north shore of the estuary affords expansive views of big skys.

Patrinton, the capital of southern Holderness, is dominated by the 200-foot spire of St Patrick's parish church. It is a busy village worthy of a detour from the shore.

At Paull things change. The right-angle bend of the estuary requires guarding and guidance to shipping. Fort Paull provides the former and four lights, two operational, marking the Hedon Haven and Paull Holme Sands. It is 10 miles to the Humber Bridge by boat. The bright lights of the Lindsey oil terminal twinkle at dusk 5 miles away to the south, on the north Lincolnshire coast.

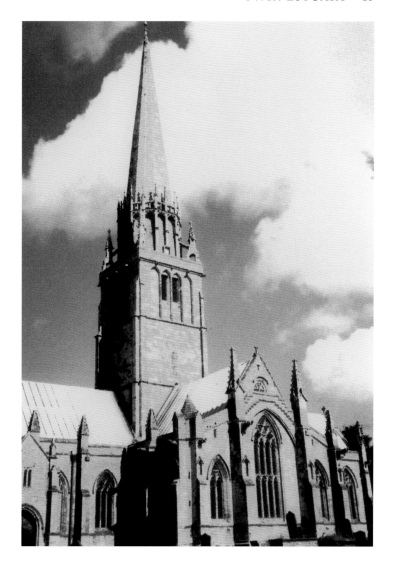

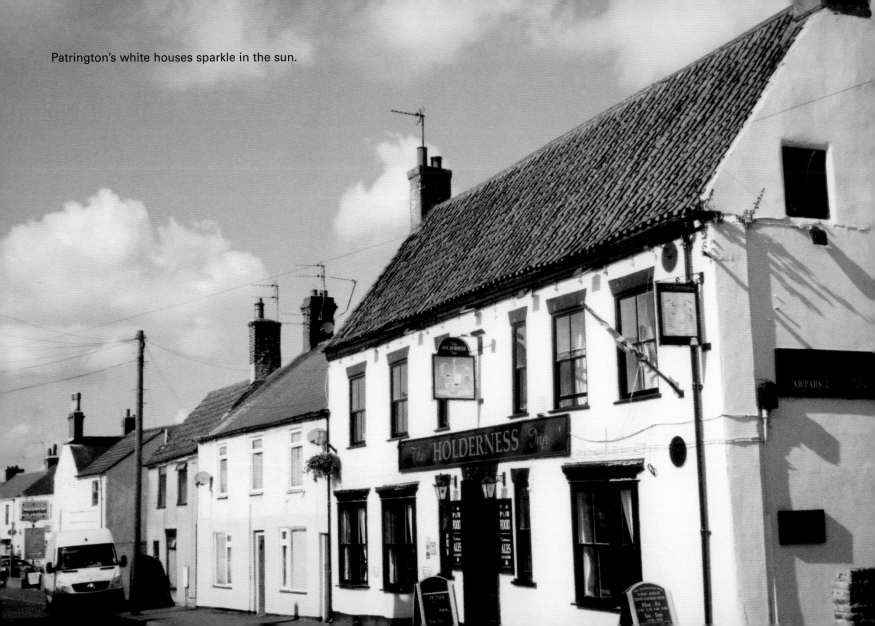

Patrington's white houses sparkle in the sun.

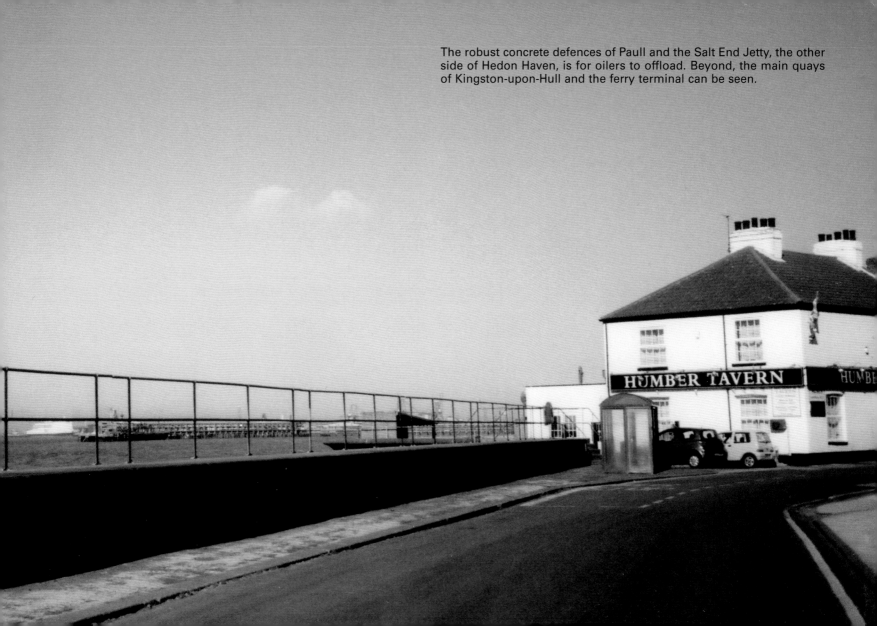

The robust concrete defences of Paull and the Salt End Jetty, the other side of Hedon Haven, is for oilers to offload. Beyond, the main quays of Kingston-upon-Hull and the ferry terminal can be seen.

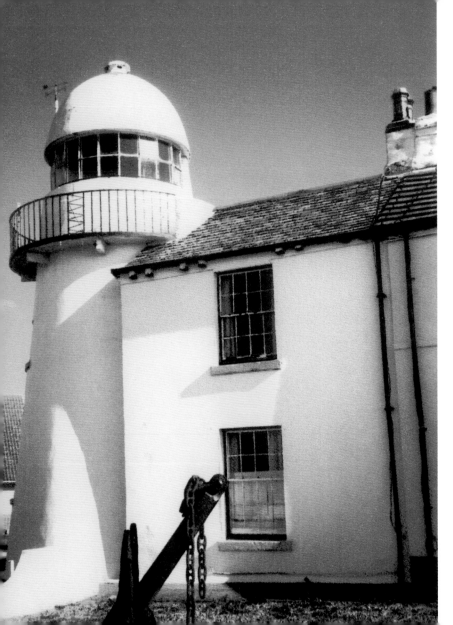

Paull had a tradition of shipbuilding as Hedon Haven offered shelter. It was owned by the Holme family until 1928. In the Napoleonic Wars a seventy-four-gun ship, 1,741 tons, was launched. It was named after one of Staffordshire's greatest Spurn Head to Trent Nessadmirals, HMS *Anson*, whose family estates are at the confluence of the Sow and Trent – 162 miles away upstream at Great Haywood.

Three lighthouses can be seen at Paull: one in the village (*opposite*) and two modern lights by Paull Sands. The first dates from 1836, but due to the shifting sands in Paull Roads it became ineffective by 1870. It was decided to place a high and low light just to the east of the village at Thorngumbald clough – one red the other white to aid shipping today.

Between the modern lights and the village is Fort Paull. Part of Henry VIII's coastal defences, it has seen service up until 1950, and it houses a unique piece of aviation history – the world's only surviving Blackburn Beverley, built in Brough *c*. 1960 further up the Humber between Hull and Goole.

Fort Paull looks across the 2-mile-wide Paull Roads to Skitter Point in Lincolnshire. Most of the fort dates from 1864 and its guns could fire over 2½ miles as it ran on special slide carriages to allow maximum engagement. Additions were made in 1894 and again in 1939. Its 3.7-inch guns (*as seen overleaf*) were dual purpose to engage aircraft and ships.

Fort Paull has been preserved by a voluntary trust and is open most days. It has fascinating artifacts and affords good views across the estuary.

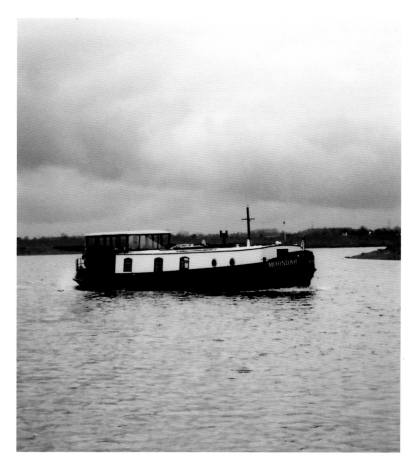

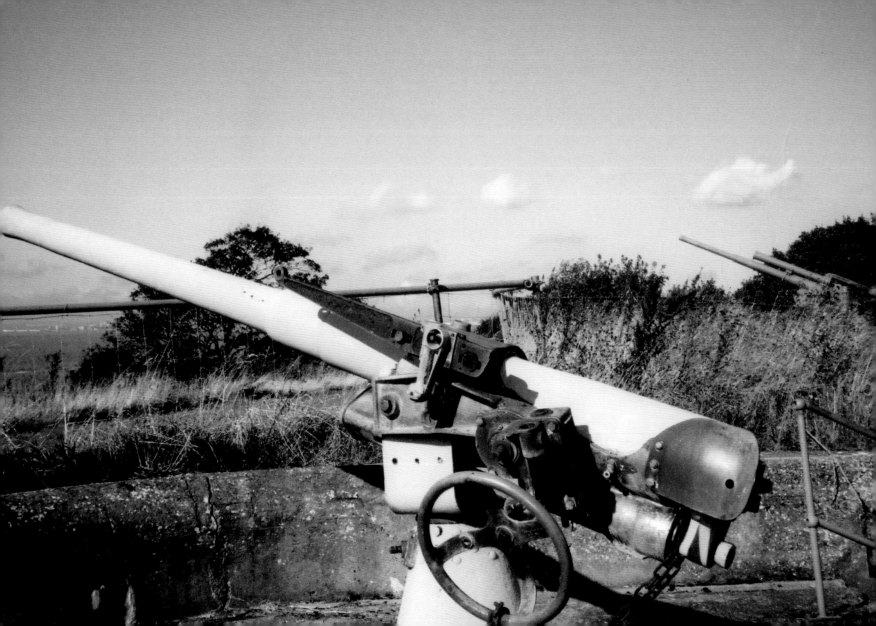

# TIDAL TRENT – ALKBOROUGH FLATS TO NEWARK-ON-TRENT

Alkborough, the site of a Roman camp, erroneously called Countess Clare. It overlooks the Strather Ridge above the floodplain, the Alkborough Flats.

*Left*: The church at Alkborough.

*Facing*: Julian's Bower, an unusual turf maze, was made by the monks of Spalding priory. It is said that on a clear day the towers of York minster 25 miles away can be seen from here. The Flats have been partially returned to marshes for waterfowl.

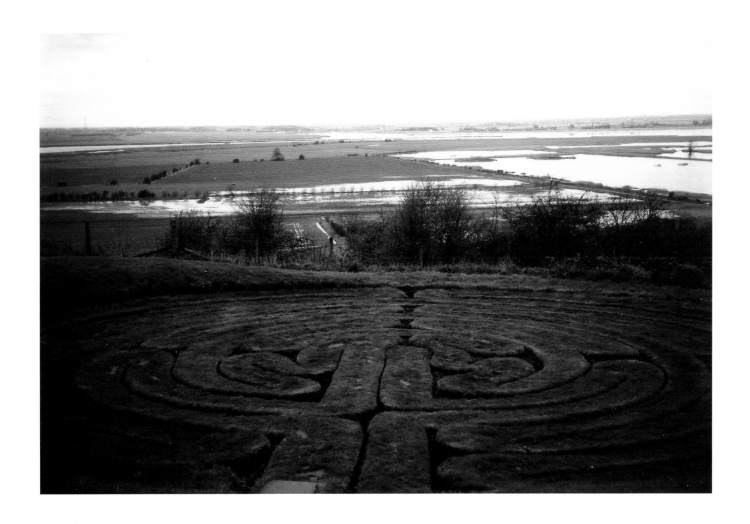

*Left*: One of the residents of Normanby Park will give you a loud and colourful reception. Once the seat of the Sheffield family, it is now a County Park. They were raised from mere knights to marquises under King William and Queen Anne. Eventually they were given there recreated Duchy of Buckingham hitherto held by the Staffords. The previous duke was wrongly accused of treason, but was executed for political reasons on false evidence. The Staffords were eventually elevated to Earls in 1681 and their original lands, much of central Staffordshire, were restored.

*Facing*: Seagoing vessels can berth at Flixborough Wharf or Gunness as the *Africa May* has to offload cargo 48 miles from Spurn Point. It is only due to the 'locking' of the King George dual railroad bridge at nearby Althorpe that prevents Gainsborough being reached another 17 miles upstream. It was an important Baltic trading port.

## BURTON-UPON-STATHER

The small village perched atop of the ridge (the Stather) has two apparently strange elements. The first is the Sheffield Arms by St Andrew's parish church and the second is the wharf called Burton Stather just below the village.

The pub was known as The Bull Inn up until 1902 when the Normanby estate passed to the Sheffield family, which included most of the village too!

The Ferry Inn at Burton Stather connected with Frockerby and was named after the first ferry over the Trent after Trent Ness.

Nearby concrete troughs can be seen that are the size of a large vehicle. These were built in the early 1940s and were part of the development of 'Hobarts Funnies'. These were specialist Royal Engineer tanks for dealing with battlefield obstacles and heavily protected fortifications. One Sherman tank mark was the D. D – Duplex Drive – which allowed it to 'swim'. First used on D-Day in June 1944, it was necessary to train other army units such as the Staffordshire Yeomanry for the River Rhine crossings. The Trent at Burton Stather resembled the current and width conditions of the Rhine. 'Operation Plunder' took place on 23/24 March 1945, led by the D. D tanks.

At kead by the Stainforth Canal from Doncaster joins the Trent. The flight of locks go up to river level.

The Isle of Axholme was drained by Vermuyden in the late 1770s and he diverted the River Don to Goole, creating a new river Thorne, Thorn and Idle channels. Known as the Three Rivers, they outflow here too.

*Opposite:* Flixborough Stather had the nearest wharf to the growing Scunthorpe steelworks, offloading iron ore shipped from Sweden and loading finished steel for use elsewhere in the UK or exported.

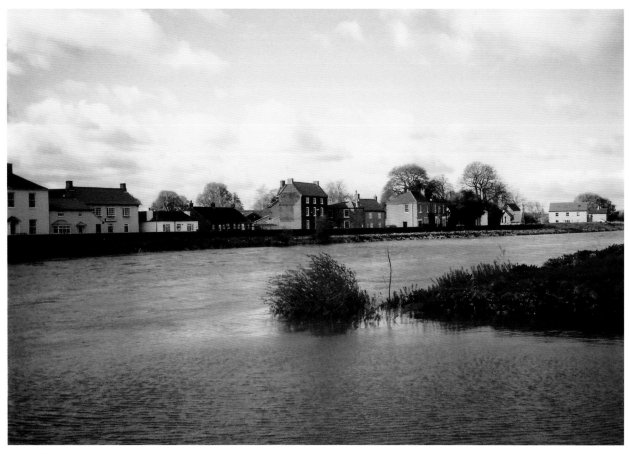

East Ferry from Owston Ferry. There were six ferries between Althorpe and Gainsborough. It is a 20-mile gap between the only two bridges on this lower part of the Trent. A high tide is backwashing upstream to East Stockwith.

Albion Place, Owston Ferry, is 3 miles from Epworth, capital of the Isle of Axholme and birthplace of the Wesleys, who were founders of Methodism *c.* 1740.

A spring tide heads south towards Gainsborough at West Stockwith. Imagine the full Aegir wave! The reeds, rushes and osiers rustle as the wave goes by.

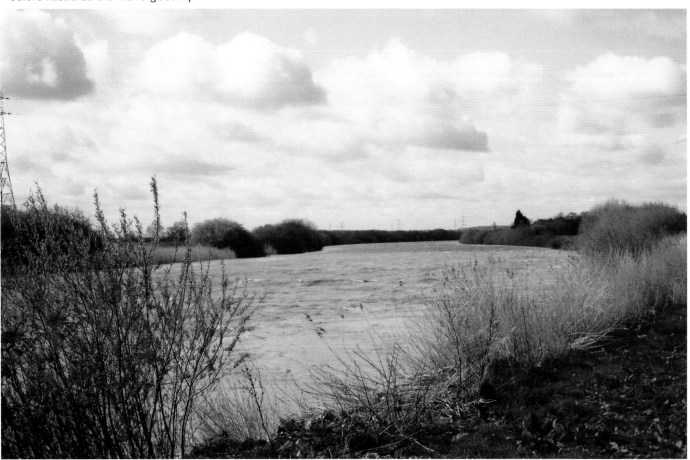

East Ferry may have had the manor court, but its parish church at Laughton has a link to Italy Angels. The Meynell-Ingrams gave funds to restore this church. An alabaster effigy of Lady Ingram has a 'twin' at the family seat of Hoar Cross in the valley of Staffordshire's smallest Trent tributaries, the Swarbourn in the heart of the Needwood Forest, 165 miles upstream. Laughton Forest, planted by the Forestry Commission, covering Jerry's Bog or Scotton Common (it's not clear which exactly). This is very unusual in this part of Lincolnshire. The Jenny Wren Inn at East Ferry was the manor court and site of hangings too.

At West Stockwith, the Chesterfield Canal branches off near the confluence of the River Idle. The county boundary marks our entry into Nottinghamshire on the west side of the Trent. Lincolnshire is on the Eastern side. The Isle of Axholm is very much chapel country – even the churches look like chapels. Epworth is 2.5 miles away near Hatfield Chase – the site of a battle in 633 between King Penda of Mercia and Edwin of Northumbria. Nine years later, the Battle of Trent was fought hereabouts.

# The Trent Aegir

Gainsborough Town Council

The Aegir - a tidal bore or wave travelling up to 12 miles per hour with water levels rising from one to five feet.

The spectacle is one of foam-capped waves breaking at the sides and crashing against wharf and craft. It varies in size and shape at different points along the river. There can be as many as nine rolling waves, known as 'whelps', in close formation. An opposing breeze will cause the waves to break and roll over with a dull roar that can be heard two miles away from the approaching bore. In the days of small craft it was custom to shout "Ware Aegir!" to warn of its approach.

The Aegir is named after the god of the seashore or ocean in Norse mythology and like the Scandinavian sailors in the myths, river people also fear the Aegir as it is very unpredictable and would sometimes surface to destroy ships. Sometimes the tide merely changes the flow of the river, but at its best, the wave breaks with fury as it passes by and can cause damage to boats.

In 1013, the Viking King of Denmark, Sweyn Forkbeard, together with his son Canute arrived with an army to conquer the Danelaw and ultimately England. He moored his ships in the haven at Morton Bight, near Gainsborough, and marched his force to the nearby encampment on Thonock Hill. A year later upon Sweyn's death, Canute became King and it has been suggested that it was The Trent Aegir that was responsible for Canute getting his feet wet by trying to turn back the tide, not the sea.

The most reliable time to see the Aegir is after a long period of dry weather. It usually appears during high spring tides, but the scouring action of winter floods and above average water levels in the river can reduce its size considerably.

**Recommended viewing positions are:**

Gainsborough, where viewing is from the Riverside Walk. There is off-road parking and it is the most suitable location for wheelchair users. Best viewing points are Whittons Gardens, Trent Bridge and the Public Footpath on the West bank.

The Aegir is also clearly visible at Morton, West and East Stockwith and East Ferry, but there is only roadside parking in these villages.

There is a risk of flooding after the initial bore wave has passed, as water levels rise for about an hour. High tide occurs after that time. Observers should take care where they stand to watch the bore.

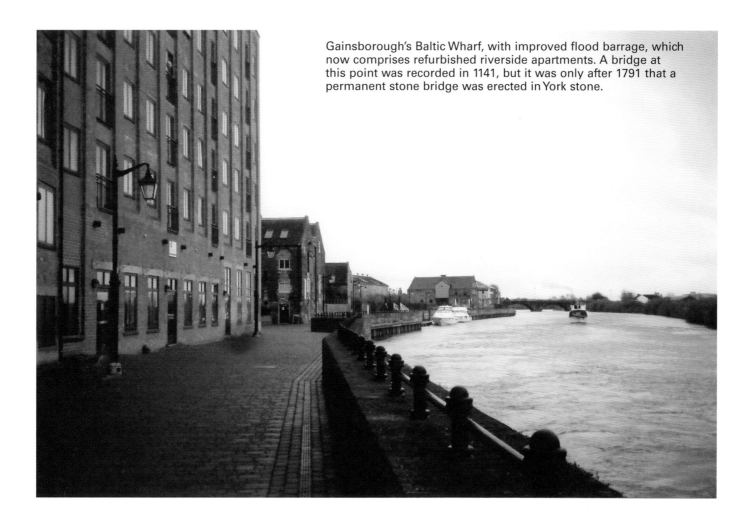

Gainsborough's Baltic Wharf, with improved flood barrage, which now comprises refurbished riverside apartments. A bridge at this point was recorded in 1141, but it was only after 1791 that a permanent stone bridge was erected in York stone.

Town Hall and Market Place in West Lindsey's capital, Gainsborough.

Wharfside memories in Gainsborough. Until the locking-down of the King George V swing bridge it was a island and sea port. Cargoes offloaded for Newark, Nottingham and beyond. Grain and other agricultural produce headed for Hull. The First and Second World Wars ensured the death of most of the Baltic trade.

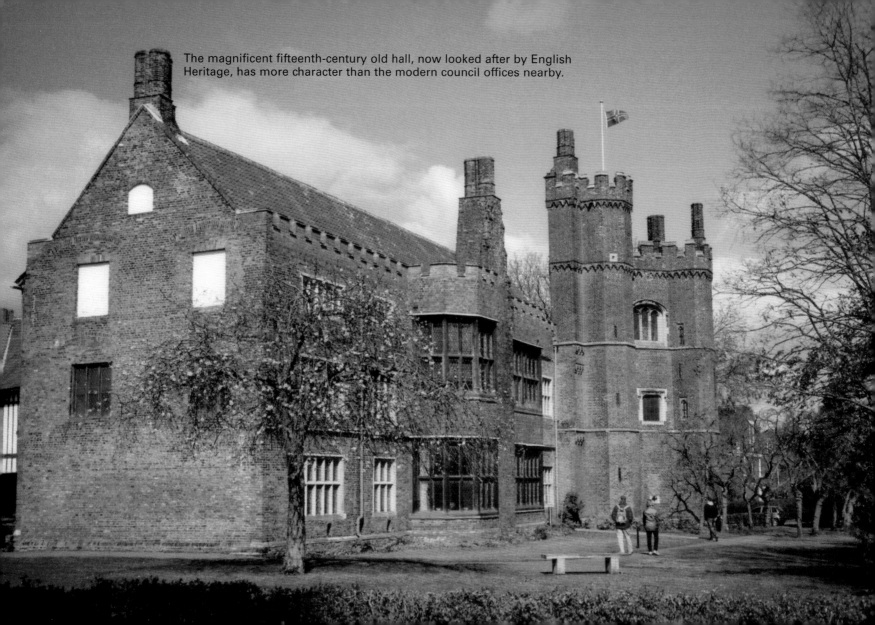

The magnificent fifteenth-century old hall, now looked after by English Heritage, has more character than the modern council offices nearby.

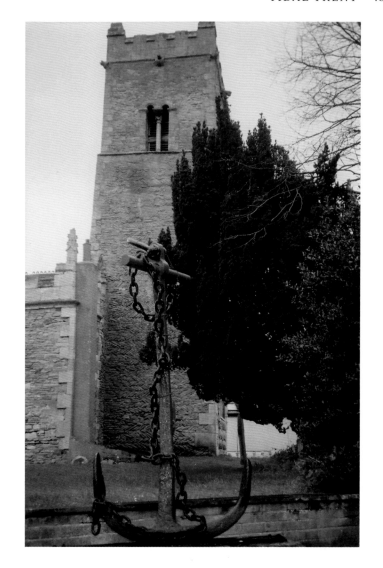

*Above*: All that remains of Trent Port today. Beyond the trees is the Roman road down to the ford from Lincoln from the east, and across the river to Littleborough.

*Right*: The unusual herringbone construction of the tower of St Margaret of Antioch dates from the eleventh century. The blue anchor was dredged out of the river and is of the admiralty design.

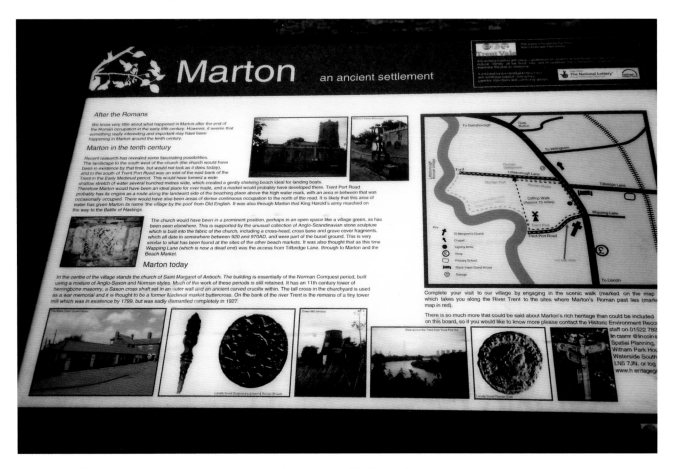

Marton and its neighbours, Upton, Sturton and Brampton, all indicate Saxon origins.

## TRENT PORT

Littleborough is on the west bank. It was connected by a ferry and a ford. The ford was first established by the Romans, as was the Humber Ford, close to the present position of the suspension bridge.

Marton is proud of its past and presents some of its history on a well-illustrated board on Trent Road near the blue anchor. It was partly funded by the Trent Vale Initiative which has tried to join the communities if the lower Trent Valley together, many no longer connected by their common ferry, now estranged by the one thing which had for centuries united them. Sadly due to austerity measures this worthwhile project ended two years ago and so the mid-Trent Valley didn't even get a look in. Thus access from between Upper Falls and Trent Lock is much hampered.

*Above*: Stow minster, once the seat of the Bishop of Lindsey, is 3 miles off the Trent from Marton. Lindsey was incorporated into Mercia shortly after the Battle of River Trent in 679. King Æthelred fought the Northumbrian forces and killed his brother-in-law in the battle. This he regretted and began a lifelong patronage of Bardney abbey, east of Lincoln, by way of penance. Stow was the seat of the Bishop of Lindsey, part of the province of Mercia centred on Lichfield.

*Below*: Torksey Castle guards the historic Foss Dyke waterway linking the Trent to the Withim. Built by the Jermyn family in 1560, it was near the earlier port which thrived in medieval times. The castle was a Parliamentary garrison in the Civil War and was slighted by the Cavalier forces, not Oliver Cromwell as were Newark and Nottingham castle.

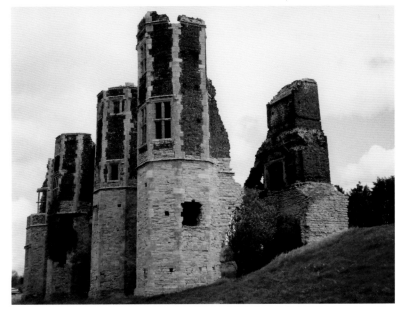

The broad moody skies of the lower Trent Plain. Torksey faces Sherwood Forest on the west bank of the river.

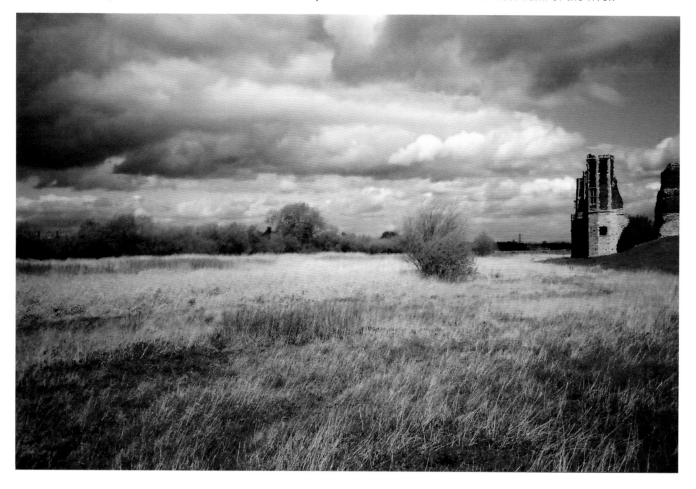

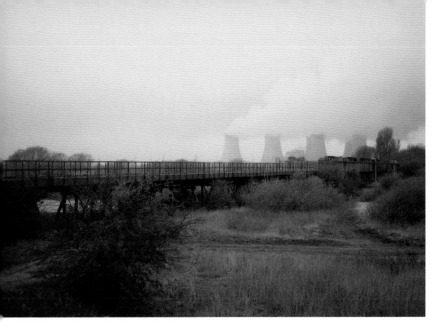

*Left*: The Torksey Viaduct, an iron-girder bridge built by the Lincoln–Doncaster Railway, is now disused since the removal of the oil terminal which was served by the Eakring Oilfield in Sherwood. We await its availability to pedestrians and cyclists to enhance access to Britain's last big river not to have a path from source to sea!

*Right*: The double flood protection locks at Torksey. Foss Dyke is Britain's oldest artificial waterway dating back to Roman times, linking the city of Lincoln via the River Witham to Boston on the coast, and the Midland waterways which join the Trent above Newark.

Six sentinels of the megawatt power station at Cottam on the west bank of the Trent. It is the largest coal-fired power station in the the UK now that Drax on the Wharf/Ouse is biodiverse.

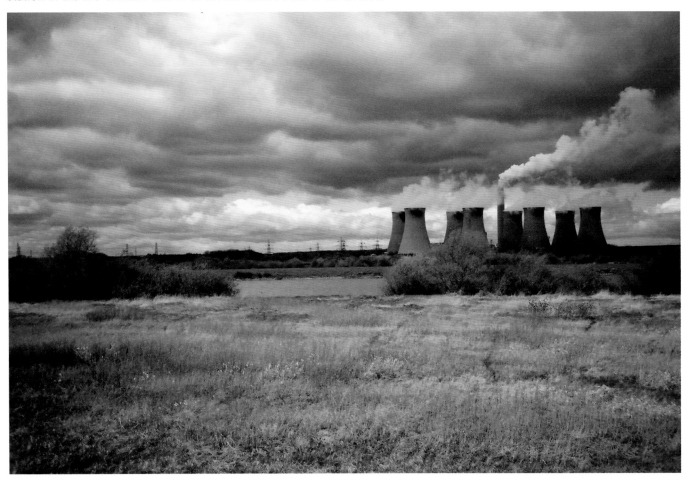

Looking west over the Fledborough Viaduct, built by the Lancashire, Doncaster and East Coast Railway, joining Liverpool to Lincoln. Seen from the first girder span, of which there are four of the twenty-six of the brick arches on the Nottingham side, which equates to nine million bricks. It is part of the 'Dukeries Trail' linking Sherwood with Lincoln.

St George the Martyr at Clifton is unusual in that it is sited between the separate north and south parts of the village and is overlooked by the dormant coding towers of High Marnham on the western bank. The local stone has a warm glow in the sun, not unlike Cotswold stone.

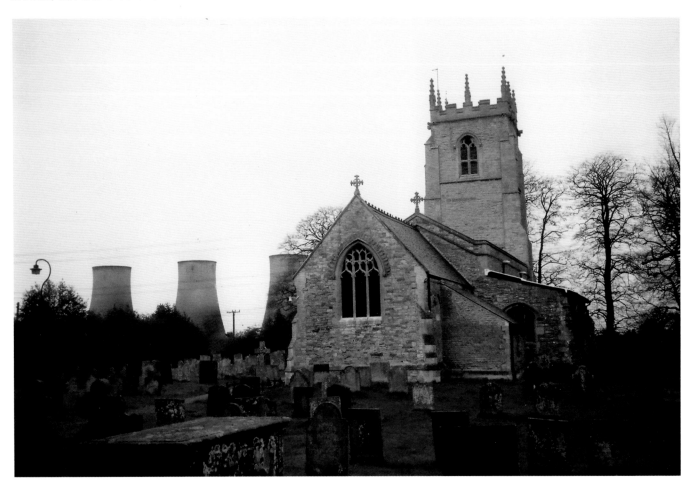

View from Fledborough Viaduct looking downstream – the silver, winding Trent. If any scene shows the generating importance this is it – 'Megawatt Valley'. The six cooling towers are of Cottam power stations. Behind us are the five giant towers of High Marnham.

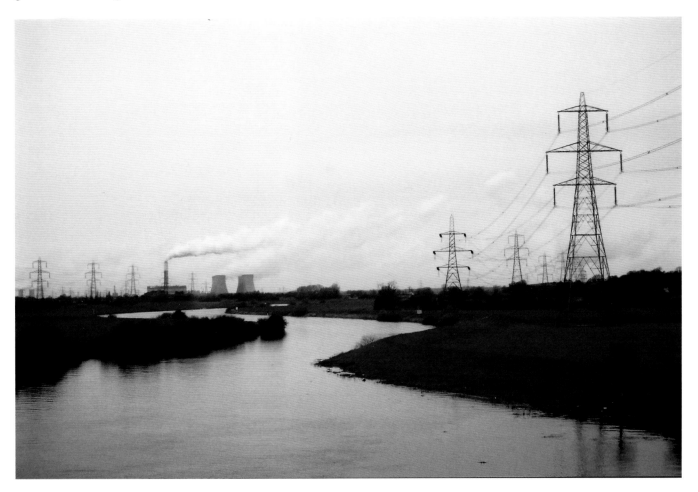

*Above*: The 'Oak Doors' – site of the medieval floodgates on the Fleet near Girton. The Trent, a mile to the west, is shown as 'Spring head'. The Fleet River was created by the floods of 1600, which moved Holme to its east bank of the Trent as a result.

*Left*: The Fleet by Besthorpe is wide and lake-like, and is lined by large willows. Besthorpe Wharf is mile down Trent Lane and was important during the eighteenth and nineteenth centuries – no trace exists today. When the Vikings came this was the Trent, hence Besthorpe being adjacent to it and not on the main channel today. Winthorpe is at the source of the Fleet further south.

Converted gravel barge *Moondah* swings through Normanton bend heading toward Torksey. The 252-foot spire of Newark's church is in the distant background on the left.

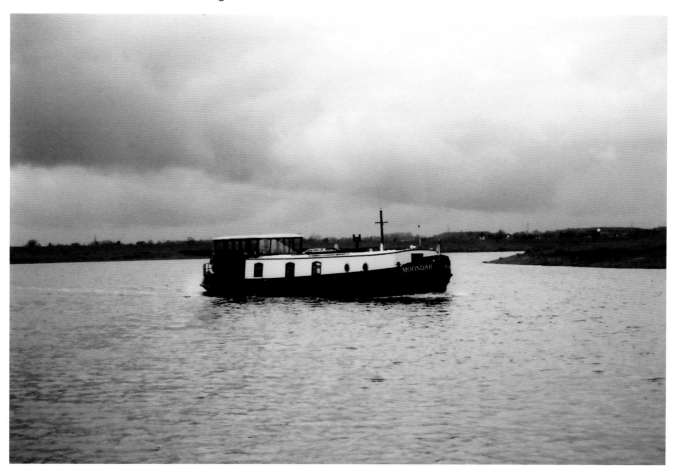

As we have seen in the lower Trent Valley the river was a unifying factor with many settlements named as 'East' and 'West' joined by the river ferry. Only today, after fifty years of the last foot ferry ceasing, do we look at the river being a barrier.

Even at the time of Danelaw, the Trent was not the boundary of its limits. Derby and Nottingham were north of the Trent in Danelaw, while Leicester, Stanform and Lincoln are the other side. Only a few parishes in East Staffordshire have Viking origins. The Dove Valley was the edge of Danelaw here.

Mercia wasn't divided by the Trent before the Danes. It was a trade route to Tamworth, which was the heart of the Kingdom. Rhinestone mill wheels have been uncovered at Offa's capital. Staffordshire's River Tame, rising as it does near the ancient Borough of Wodensbury (Wednesbury); the ancient god of the fierce Saxons and worshipped by King Penda of Mercia, not quite lost in the midst of The Black Country, drains virtually all of North Warwickshire including Birmingham and South Staffordshire east of the Sedgley–Dudley–Norwood ridge. We meet it Alrewas where the Trent sweeps it most southerly bend of all.

To extend the navigable portions of the river, prone as it was to shifting shoals and meanders, Josiah Wedgwood and Erasmus Darwin sought James Brindley to build the longest canal at the time. It was built between 1766 and 1777 and was 98 miles from Runcorn to Trent Lock.

St Giles' Church, Holme, built by the wealthy wool merchant, John Barton.

# VALE OF RADCLIFFE
# TRENT BRIDGE TO TRENT LOCK

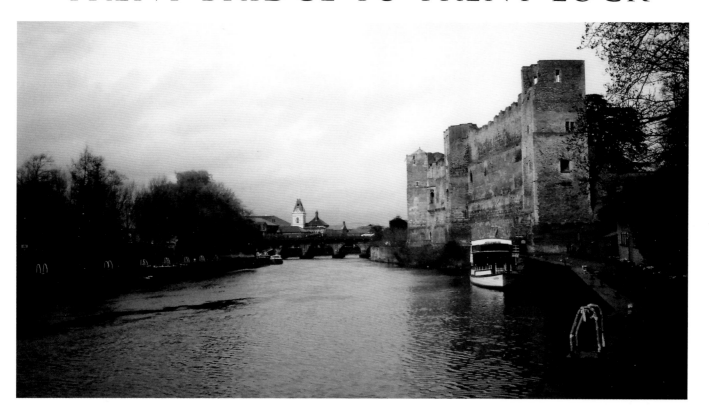

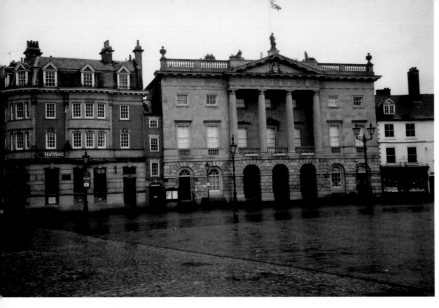

*Previous page*: Newark Castle has been at the heart of national events, guarding the Great North Road to York and beyond. King John, at the end of whose reign the Magna Carta was sealed, died here after fleeing from his recalcitrant Barons, losing 'his jewels' in the Wash.

During the Wars of the Roses (1455–87), the last bid by the Yorkists, after the death of Richard III occurred at East Stoke Heath by Foss Way. The River Trent ran red on 16 June – such was Henry VII's rout: over 6,000 men died in total that day.

Charles I arrived on 11 July 1642 prior to raising his standard at Nottingham, signifying the start of the English Civil War. Newark was a Royalist garrison that was besieged several times by Parliamentary forces. It was heavily defended by earthworks, including the King's and Queen's sconces. On 5 May 1646, King Charles left to go to Southwell to surrender, and three days later his commander in Newark did the same.

*Above*: Newark-On-Trent has one of the largest market squares in Britain. The Town Hall dominates one corner. Just beyond and diagonally opposite, is the parish church of St Mary Magdalene, an early English masterpiece with its 252-foot spire.

*Below*: Newark's Docks sprung up by the castle where the Farndon cut was made to shorten the journey on the river and avoid many shoals in the process.

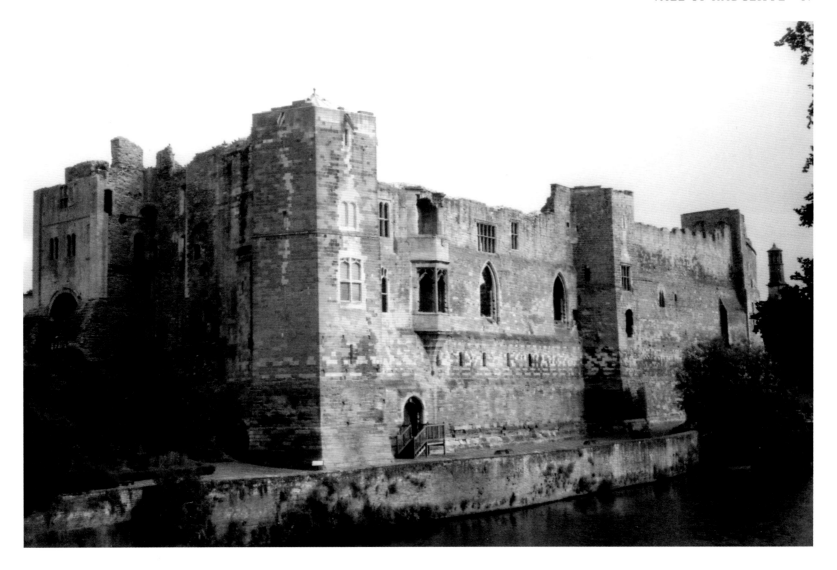

*Above*: A narrowboat heads upstream to Fiskerton from Farndon passing the large weir at Upper Water Mouth, Staythorpe. Hazelford Lock and Weir is on the north side of Hazelford Island. This is the first lock of four between Upper Water Mouth and Trent Bridge.

*Below*: The Staythorpe weir is a fifth of a mile long and is the longest on the Trent. Here the river bifurcates, although the old south channel (Old Trent Dyke) has been replaced by a new one, thus cutting 5 miles off its course.

*Right*: Trent Lane by Kneeton church led to Hoveringham Ferry, one of six ferries between Nottingham and Newark-on-Trent. There wasn't a road bridge until 1873 at Gunthorpe.

*Below*: The Trent Hills are created of hard red sandstone and form an escarpment running south-west to north-east from Radcliffe-on-Trent to Farndon. Radcliffe means Redcliffe – an outcropping of ubiquitous red Triassic sandstone in many parts of the Trent Valley. Here the juxtaposition of Saxon and Viking settlements are most pronounced – Bleasby and Thrugarton, Syersten and Sibthorpe, Shelford and Gunthorpe. Kneeton church (below) is near the highest point on the 12 mile edge at 243'OD. The valley floor is below 90' but the gradients are acute.

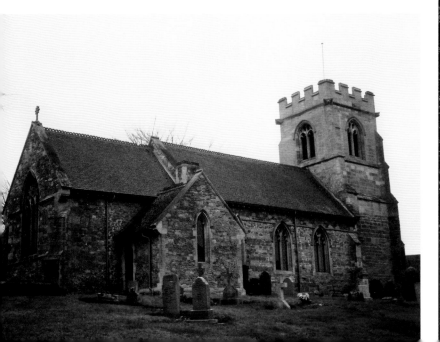

*Left*: The Gunthorpe Ferry was augmented by a toll bridge in 1873, but was damaged by use and flooding. A new County Bridge was built further upsteam in 1925, carrying the A6097 to East Bridgeford. As with the twentieth-century replacement bridges in Nottingham, it was built of reinforced concrete.

Between Colwick and South Muskham all the villages are sited on the north-west, joining streams into the Trent in the Vale of Radcliffe. These were in the Wapentakes of Thurmaston and Lythe, Lowdham on Cocker Beck, Caythorpe on Dover Beek, Hoveringham on Causeway Dyke, Bleasby on Holme Dyke, Morton and Fiskerton on the Greet Rolleston on Rundell Dyke and Averham on the Pingle Dyke.

*Right*: Snowdrops in Shipman's Wood Trent Hills – one of many copses on the steep edge.

Flintsham Wood near Hazelhurst Island has the infamous Red Gutter or Bloody Brook of the Battle of East Stoke (1487, Wars of the Roses.) Emerging from the Colwick Narrows the Trent makes huge sweeps across the floor of the Vale, the largest over 3 miles in length bouncing off Red Cliff to Burton Joyce 2 miles west of Gunthorpe to then create a wide bend at Shelford. 100 feet above Shelford is RAF Newton, similarly placed to RAF Swinderby.

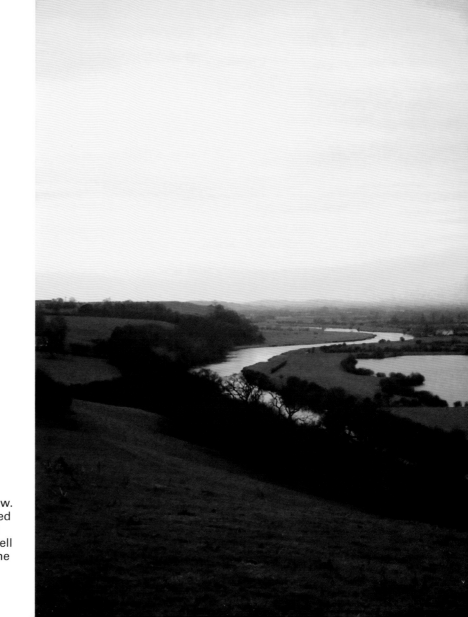

Toot Hill (lookout hill) is the highest point on the Trent Hills. This is sheep country up on the edge, with arable farming in the vale below. The small River Greet flows in from Southwell. The breeze generated by the warmer air in the vale has proved useful to the RAF and the stationing of the Gliding School at RAF Syerston is particular. As well as hares gambling in the frosty fields and pheasants scurrying in the woods, the gliders taking off are equally as fascinating to watch.

Busy Gunthorpe Wharf just above the lock and weir below East Bridgeford. The stone abutment of the iron bridge, built in 1873, can be seen directly across the river adjacent to the Ferry Inn. The flow is left to right on this calm day, even though a weir and lock are only a few hundred yards downstream. The willows here haven't leafed as much as those on Biddulph Moor yet.

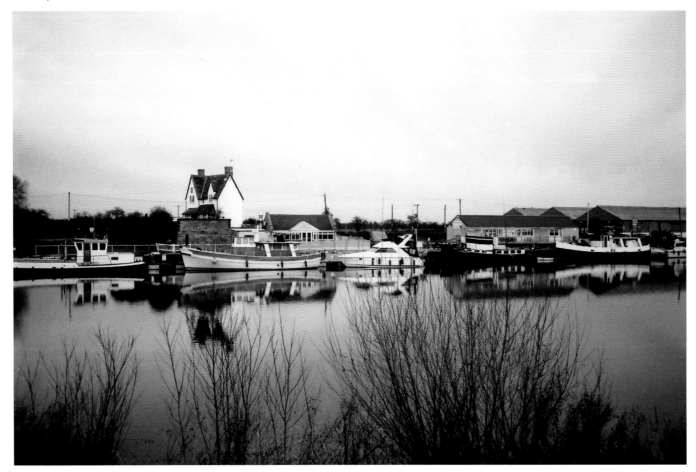

*Right*: The only trace of ferry equipment abandoned in the 1960s. Typically, the pub is on the wrong side! Nottinghamshire's Trent Valley Way follows the top of the flood dyke to Radcliffe-on-Trent. The ferry was like a large raft which could carry a farm cart or small car in the twentieth century.

*Left*: Shelford was a Royalist stronghold during the Civil War, held by the Earl of Chesterfield. Upstream at Holme Pierrpont the Earl of Kingston's family were split between King and Parliament.

Stoke Bardolph's Ferry Boat Inn is still popular today, but is no use to riverside path walkers – press on to Radcliffe-on-Trent.

Radcliffe-on-Trent takes its name from the red cliffs that overlook the Trent hereabouts. An important weir regulates the river, and the lock was built in 1922 after Nottingham had suffered severe flooding. There is no road bridge at Radcliffe, but a railway viaduct from Carlton spans the river.

The course of the river is as if the current has bounced off the hardened sandstone wall of the cliffs to force it north across the valley floor. The Hams are thus created: the wanderer goes off east towards East Bridge Ford before assuming its north-easterly alignment to Newark-on-Trent.

Keeping it in check for the most part of the 10 miles, between Gunthorpe and Farndon, is the band of hard Red Bunter sandstone that forms the Trent Hills. From Toot Hill broad panoramas over the Vale of Redcliffe can be seen, including views of Caythorpe, Hoveringham Thurgaston and Bleasby. The small River Greet flows in from Southwell near to Fiskerton.

Next to Radcliffe is Holme Piemepont, once the seat of the Earls of Kingston. They were Lancastrians in the Wars of the Roses and William Pierrepont fought against the Earl of Lincoln's forces at Stoke Heath on 16 June 1487. Henry VII commanded 12,000 men while the Yorkist force of 8,000 had to cross the Trent, wading it at Fiskerton. Many tried to retreat during the engagement across to Hazelford and were slain in the steep narrow cleft known as Red Gutter.

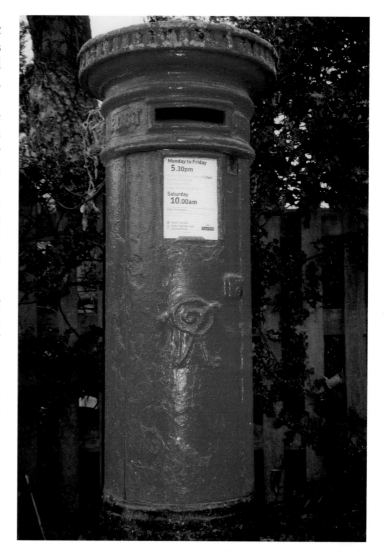

A rare Victorian pillar box on Radcliffe Lane from Holme Pierrpont.

Colwick Weirs and Holme Pierrepont. Unable as we are to cross the river at Stoke lock/weir, the thoughtlessness of a megalithic body as the National Rivers Authority bars any possibility from reaching Colwick Hall and Country Park. Now that would have been a useful millennium bridge, but hey, this is only the Trent, which is bigger than the Tyne or Thames yet gets overlooked time and time again, for no better reason than its still regarded as a canal extension and open sewer – an object to be exploited by despoliation. Well it isn't anymore and it deserves renovation and protection. It has been left at the margins for too long, as if a mere backwater to do man's bidding and nothing else!

Nottinghamshire wanted to celebrate the 100th anniversary of their county council, but Leicestershire didn't, and neither did Derbyshire, so the Trent Valley Way stops at Thrumpton under the Red Hills.

*Facing*: Beyond the Fabis Hills is Leicestershire's Soar valley – the Trents largest southern tributary since the Tame and Mease at Mytholme near Alrewas. Barton Moor, Ruddington Moor and Bradmore occupy the low gap that once took the prehistoric Trent to the coast via the Ancaster Gap north of Grantham. The Soar rises near the country boundary with Warwickshire near Bedworth. Its two tributaries flow into it north and south of Leicester – the River Wreake and Sence, respectively. The Soar Navigation is a mixture of improved river and lengths of Grand Union canal.

View from the Red Hills looking to Clifton Cliffs and Nottingham, with the Barton Moors off to the right. Below the wood is Thrumpton Hall, home of Lord Byron and the start of Nottinghamshire's Trent Valley Way. Pity they didn't tell Leicestershire at Ratcliffe-on-Soar! Quite a view from 236!

On top of Red Hills and an oasis of mature Beech trees. The thunderous sound of Thrumpton weir below permeates the wood from the north. And the rumble of the passing trains from Trent Junction over the Cranfleet Viaduct and through the tunnels south to Loughborough. Behind is Ratcliffe-on-Soar power station's eight giant cooling towers, which can be seen many miles away.

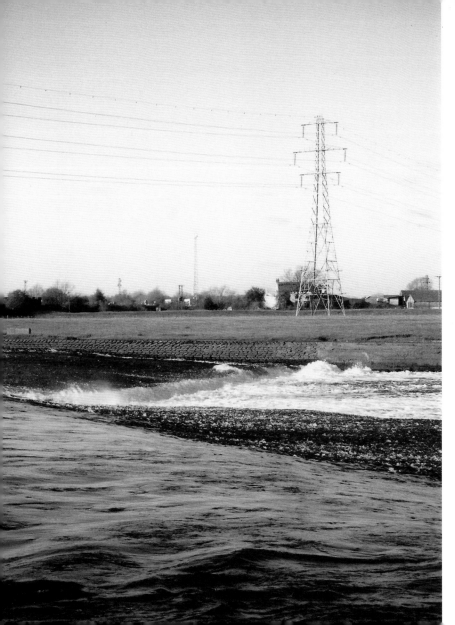

*Above*: The new cut bypassing Thrumpton Weir at Trent Lock at the confluence of Leicestershire's River Soar and Erewash Canal – a coal canal beginning at Eastwood.

*Left*: The thunderous gallons per second produce the spume at the bottom of the Thrumpton Weir. It was built in 1794 by the engineers William Jessop and Robert Whitwork as part of the Trent Navigation Improvement in the 71 miles to Gainsborough.

*Facing*: The Cranfleet Viaduct. Red Hill tunnels to the left, Trent Junction to the right, where five lines meet between Derby and Nottingham.

The Trent and Mersey canal properly starts at Shardlow. Stoke-on-Trent is 75 miles from here, and 86 to Trent Head in the Staffordshire Moorlands.

Shardlow was a very busy inland port with warehouses for goods trans-shipment and local canal industries such as iron-making and rope works. The splendid Horse Long Bridge has recently been renovated over the river, opposite the mouth of the Derwent – Derbyshire's longest river.

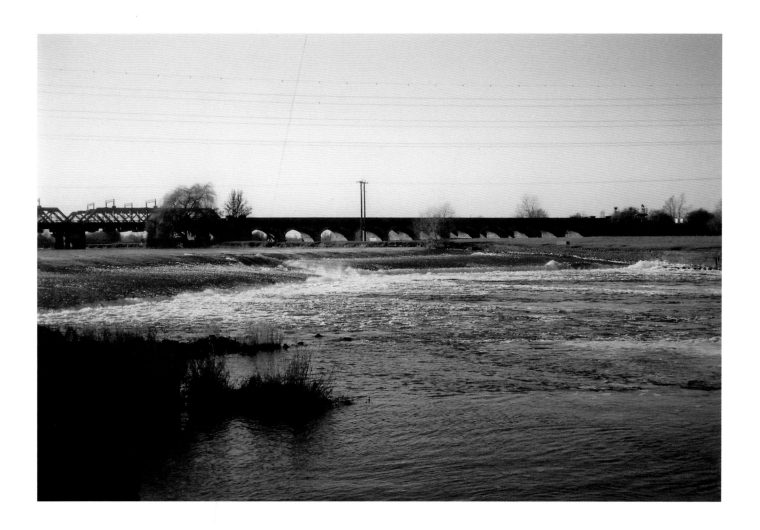

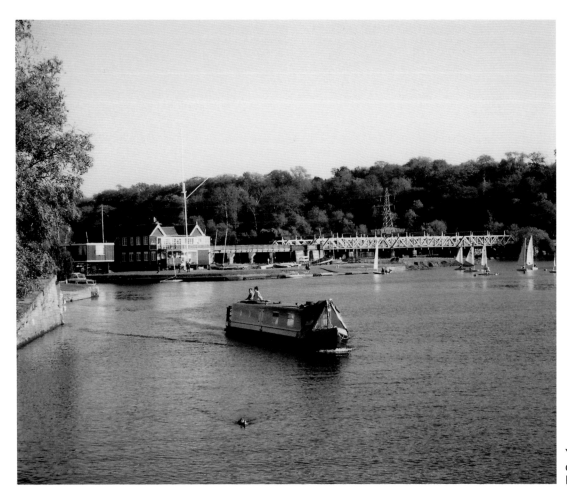

Yachting at the 'Trent Lake' created by the confluence of the Soar Navigation and Nottinghamshire's Erewash Canal (1779).

Red Hills Lock looking towards the Trent by Radcliffe-on-Soar. The River Soar is the country boundary between Leicestershire and Nottinghamshire.

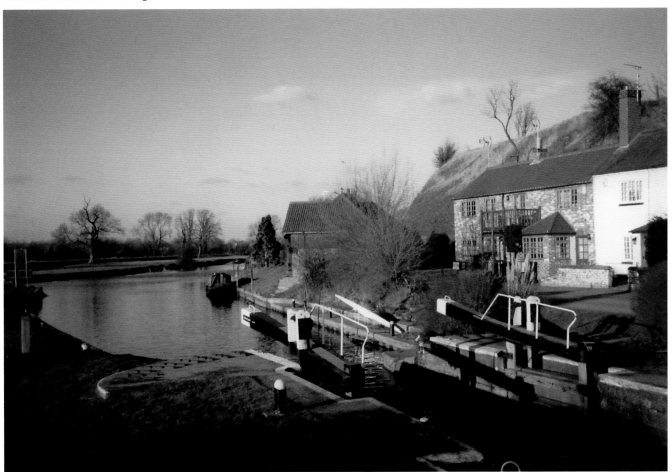

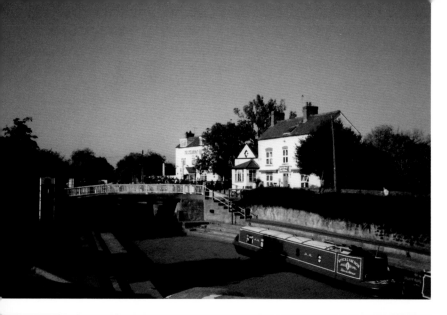

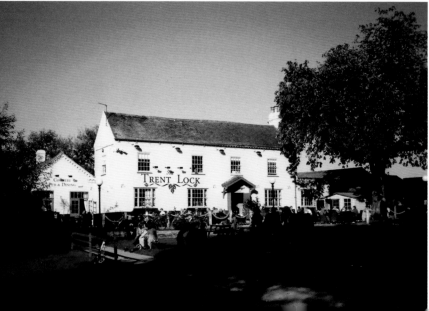

*Above*: The first lock on the Erewash Canal. Began in 1777, and 12 miles long, it was essentially built to transport coal from the eastern edge of the Nottingham coalfield to the north as far as Ironville in the Golden Valley near Ripley.

*Below*: Trent Lock is a popular weekend venue. Once, a footbridge crossed over to Red Hill Lock on the River Soar Navigation. There are two sailing clubs on the river hereabouts.

# DERBYSHIRE TRENT
# TRENT LOCK TO BURTON-UPON-TRENT

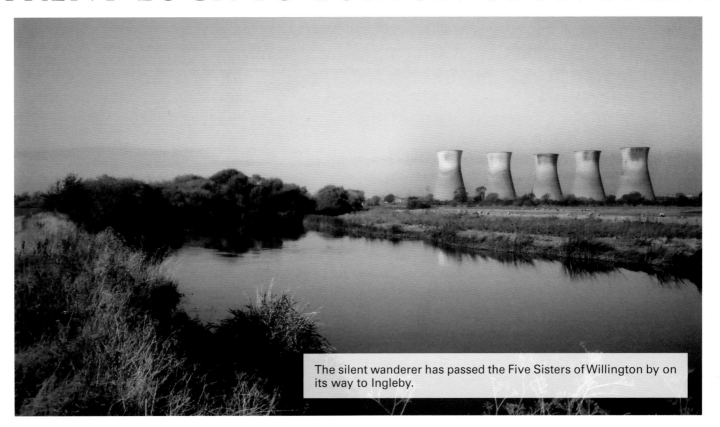

The silent wanderer has passed the Five Sisters of Willington by on its way to Ingleby.

Shardlow is a colourful port due to the narrowboats' paintwork designs. During September there is a splendid Morris gathering. Groups come as far as South Wales to show their unique sequences. The local Derbyshire Morris people put up a good local welcome to all and sundry.

Since James Brindley began the engineering of the Trent and Mersey in 1766, there have been additional pieces of civil infrastructure. One involved the replacement of the Cavendish Toll Bridge, after its central arch was washed away in the 1947 floods; a permanent replacement had to wait until 1956.

The M1 Viaduct spans the old oxbow meander and the present channel just east by the entry of the Derwent into the Trent. In the last ten years, the A50 dual carriageway has bridged the windy river, just on the edge of northwest Leicestershire and the Castle Donnington Cliffs.

Donnington power station has gone, but the access to the new A50, which provides a link between the M6 and M1, has seen the ex C.E.G.B estate taken over as a distribution park. The castle has gone at Donnington, but the Stanhopes pile at Elvaston to the north still stands in Wyatt Landscaped Park. Derbyshires country show was held here on the Whitsun Monday.

The northern boundary of the National Forest reaches to Melbourne and Stanton-by-Bridge on yonder side of the 'silvery snake', which is full of smaller slithery eels in these parts by King's Mills.

From Shardlow beyond Cavendish Bridge and the gravel workings opposite Castle Donnington are the villages of Aston-on-Trent, Weston-on-Trent and Barrow-upon-Trent. Local produce from ropes, eels, gypsum and flour were put on to craft and sent down to the wharf at Shardlow. The A5132 was the main road in this part of the valley, but if has been superceded by the A50 dual carriageway a couple of miles to the north.

A quiet section of the Trent and Mersey (T&M) canal runs parallel to the river. There are few locks, one by each village, although Barrows is more at the end of Swarkestone Bridge. It had a ford too but this is long gone since the gravel extraction began.

Swarkestone Bridge has been fought over several times, or at least defended from capture and destruction. Apart from the Second World War 'Stop line' defences of the Trent Valley and key tributaries, it was the point at which the Jacobites were halted in 1745 having ravaged Derby, Leek and Macclesfield on the way. The Duke of Cumberland was headquartered at Stafford, so they avoided the Trent Valley at Stone as it was easily reached from Stafford.

The Harpur family, who resided at Swarkestone Hall, guarded the bridge at the outbreak of the Civil War for the King. Parliamentary forces took control and attacked the cavalier garrison at the hall, turning it into a ruin. Only the twin turreted pavilion remains today.

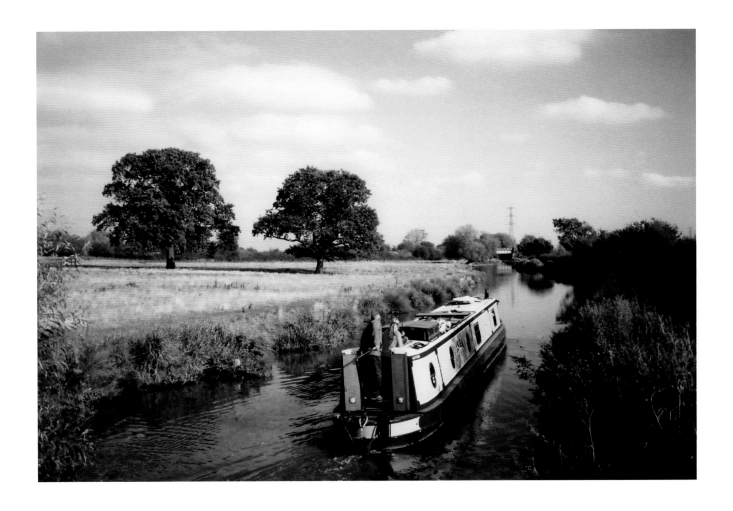

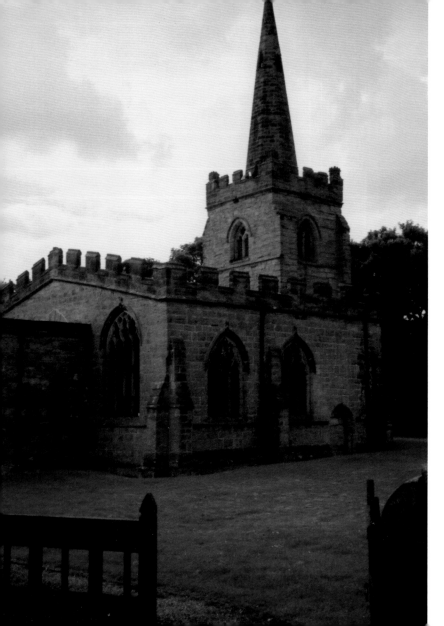

*Left*: The ancient fourth church is built on a small bluff above the Trent on the opposite bank to King's Mills, close to Donnington Park. The foot ferry featured in a Civil War episode and was the last crossed in the 1960s.

*Facing*: King's Mills below the weir. Wooded cliffs of Donnington Park overshadow the old mill houses (now a hotel). The house was built to rival Bolsover, Hardwick or Wollaton, but the family was devastated during the Civil War. In the park is a unique monument to a Queen Lady Jane Grey, who reigned for nine days. Known mainly for the racing circuit of various petrol powered vehicles and an airport, it was a prisoner of war camp during the Second World War.

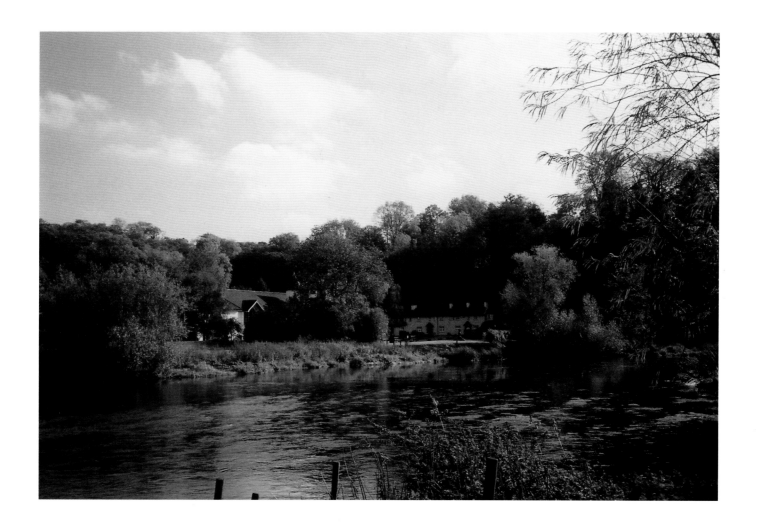

*Facing*: The river between Donnington Cliffs and Eel Island. The entrance to the stone eel traps can be made out on the right. Eels were fished a lot along the length of the Trent, often using wicker basket traps.

*Right:* The three stone entrances of the permanent eel trap channels above the King's Mills weir. In Victorian times there was a boathouse too, but the weir has been lowered since then.

Tranquil Fisherman's Beat below the King's Mill Weir looking downstream to Weston-on-Trent. Here, the ferry crossed just beyond in shoals until 1966; the ford had been abandoned a decade before!

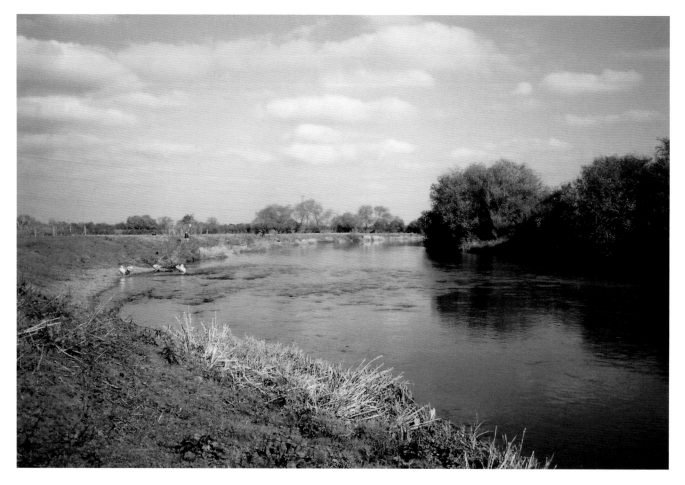

At Weston-on-Trent, canal and river are so close they only have a towpath between them at Warden Cliff. Here, the ferry to King's Newton crossed. There are thirty-two locks between Shardlow and the Trent and Mersey Canal summit at Harecastle tunnel through Congleton Edge, of which Mow Cop Castle is the highest point at 1,100 feet.

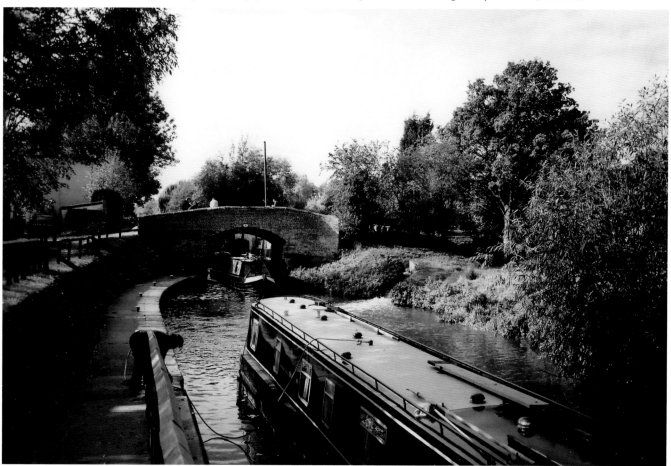

# REPTON – ANCIENT CAPITAL OF MERCIA

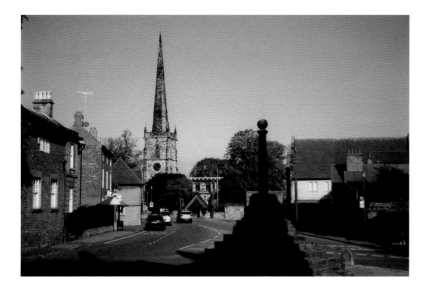

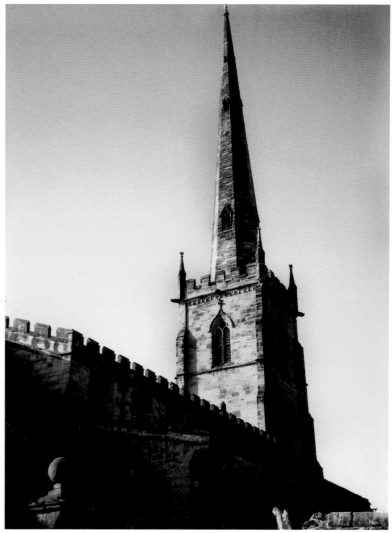

*Above*: Repton's Market Cross looking to the site of the Augustian monastery, part of Repton School now occupies this site. One famous Reptonian became world famous as the first film star to portray Sherlock Holmes – Basil Rathbone.

*Right*: St Wystan's was built over the earlier Saxon monastery, named after a Mercian saint. Here several princes and kings were buried in the crypt. The Viking great army plundered the settlement in 874/75 having sailed up the Trent.

*Facing*: Rural domestic architecture on the Newton Road from Market Cross.

Geese in the fields and the winding Trent as it shimmers
by in the late summer.

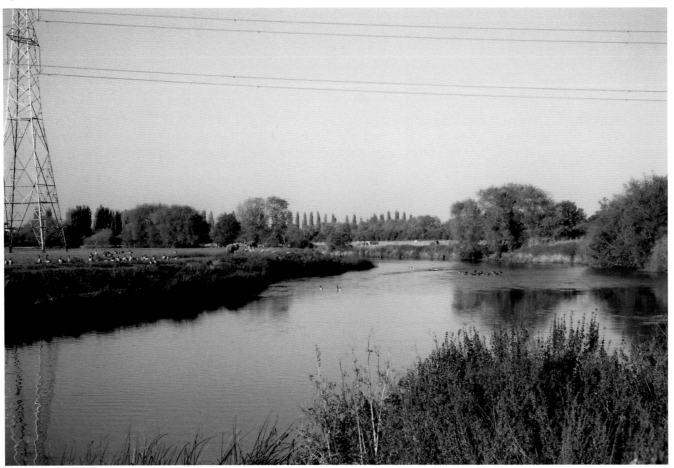

The hamlet of Twyford from across the Trent. The river has cut down into the alluvium by several yards, it is not visible at this point. The flood meadow in the foreground us testament to the mighty wanderers predilections.

The section along the Trent between Stanton and Willington Bridge is one of the most beautiful and interesting. The section is home to Ingleby, a hamlet with the John Thompson Inn (known for brewing its own beer for decades). Its striking oaks on the north bank and the mysterious Anchor church which some say was a hermitage in Mercian early days. The old Trent cuts closer to the higher ground between Newton Solney and Foremark, lapping the foot of the abbey at Repton and the entrance to the hermits cave.

Following the fishermans' path on the riverbank upstream, after Anchor bend, the spire of Twyford chruch on the north bank comes into view. Here a chain ferry, which could carry horse and cart, operated up until the 1920s. It became more popular after 1835 when parliament had granted the building of Willington Bridge, which was a toll bridge, but also the loss of the paved ford and ferry there. The 2½ inch map still shows the bridle right of way down to the river at Willington, just east of the bridge. Tolls were scrapped in 1898 when Derbyshire County Council purchased the bridge. Repton Post Office has the old Toll Board from pre-1898.

Beyond Repton are Melbourne Hills, which hide the captured waters of the Dove. An aqueduct has carried its sparkling waters over the Trent, just upstream near Newton Solney, to create these unexpected lakes, which are a surprising part of south Derbyshire. Ticknall was the source of much quarried stone, not least to build Calke abbey – now in the care of the National Trust. Much replanting has been done in the last twenty years as part of the National Forest schemes. Soon, beyond Newton, the river bends south-west and becomes the county boundary with Staffordshire.

The glorious sweep of Swarkestones five-arch county bridge (1796) continues as a fifteen-arch causeway to Stanton by Bridge – the first road bridge since Cavendish Bridge at Shardlow 9 miles back. Repton lies another 8 miles over the equally splendid Willington Bridge.

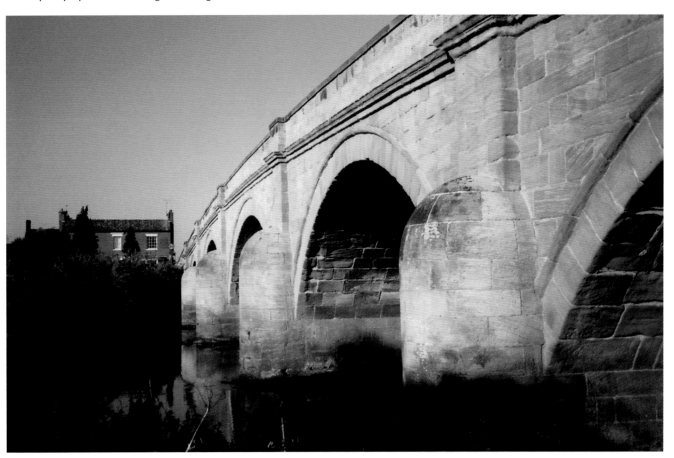

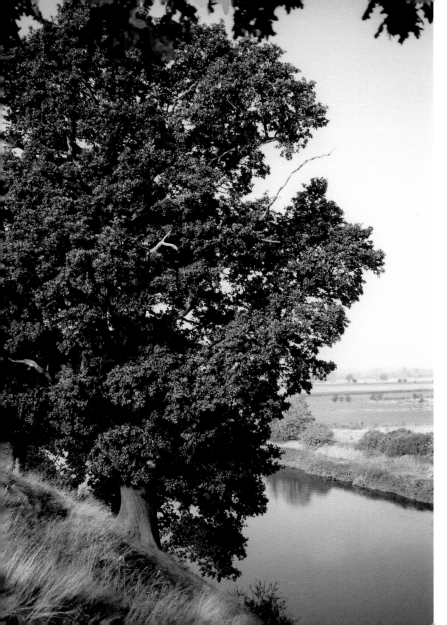

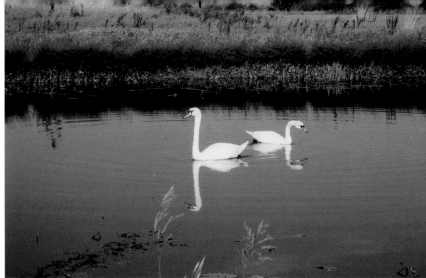

*Above*: Swans congregate near the broad Foremark 'elbow' just beyond Ingleby – a good place to view the Trent from its southern banks. The oaks along Ingleby banks are a stirring sight.

*Left*: Just around the corner is Anchor Church by the 'cut off' channel of the old Trent. The fisherman's path along the riverbank leads to the former Twyford Ferry Lane through the open meadows to reach Repton.

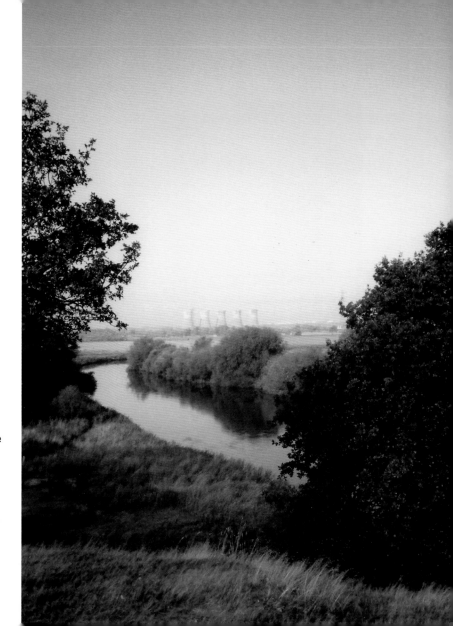

*Right*: The Five Sisters of the now disused coal-fired power station at Willington appear framed by the Oaks just before reaching Anchor Church caves in the sandstone bluff close to the old Trent channel.

Arthur Mee, in his book *Derbyshire*, writes 'the loveliest way is perhaps the lane from Swarkestone in company with the winding River Trent'.

Between Shardlow and Willington there were five ferries across the river uniting villages. Twyford is one of the most beautiful settings along this 15 mile length. Such is the popularity of the Trent and Mersey that a new marina has been created from a former gravel quarry at Willington. It is a thriving village thanks to the canal traffic, having several inns and shops.

*Overleaf*: The ancient caves near Ingleby, known as Anchor Church, guarded by the arm of the old Trent and used as summer houses by the Burdetts of Foremark; the windows even had glass in them! and on the facing page: Sunset over Barrow-upon-Trent.

The co-river Dove, the joint county boundary of Staffordshire and Derbyshire has travelled 50 miles to join the Trent near Rolleston-on-Dove. They began only 12 miles apart on different south Pennines edges. It's a pity the Severn Trent plc don't allow public use of their Hedgehog Bridge, which carries the Dove Aqueduct over the Trent. Izaak Walton in the Compleat Angler knew only too well the call of the Dove Valley

Where we will sit upon the rocks,
And see the shepherd's feed our flocks,
By shallow rivers, to whose falls,
Melodious birds sing madrigals.

Swans near the shallows of the bank on the upstream side of Wellington's fine five arch red sandstone bridge linking Repton to Derby.

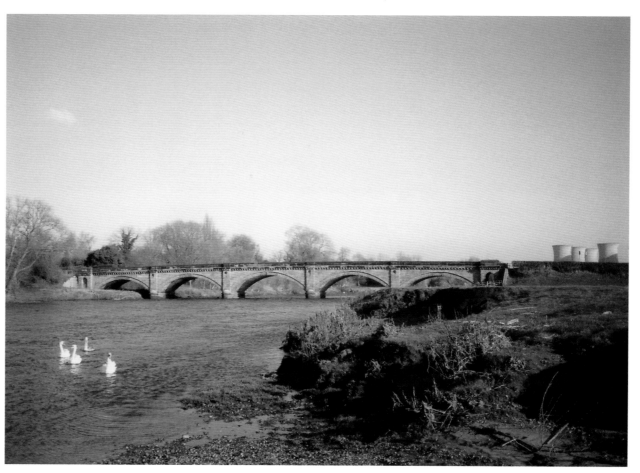

*Facing*: The former paved ford below Willington Bridge is marked
by the slight ridge in the meadow.

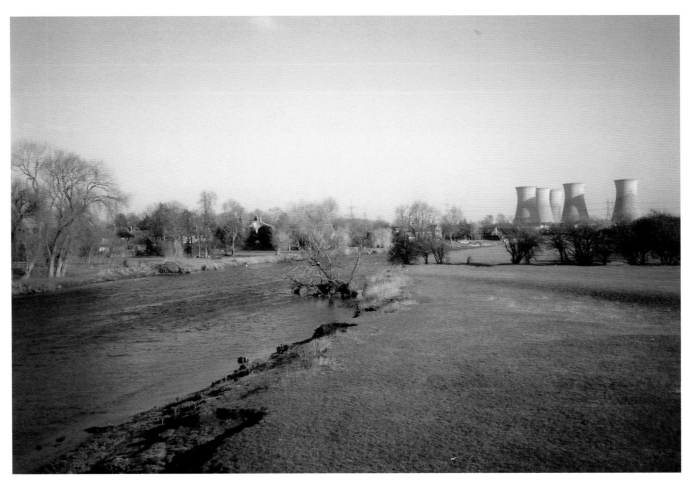

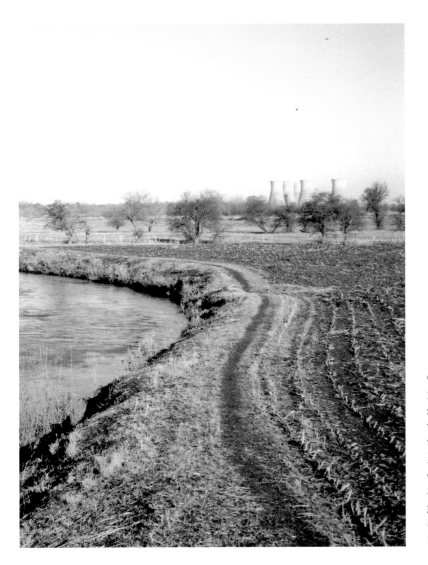

Overleaf: Art and architecture of Willington. Ospreys took a fancy to one of the Five Sisters nearly ten years ago. The image shows the graceful sleek lines of former power stations' cooling towers. They are the salient monuments to the importance of the Trent Valley as the nation's centre of power generation – Megawatt Valley. The ospreys saved these concrete cassions of air, and they have become landmarks for the many drivers along the A50 as dual carriageways are very featureless. Like giant rooks, they change position. From afar they appear to be a crowded group, but on close inspection you will see they line up as straight as a die.

# VALE OF TRENT AND THE EARLARIES
# BURTON-UPON-TRENT TO TRENTHAM

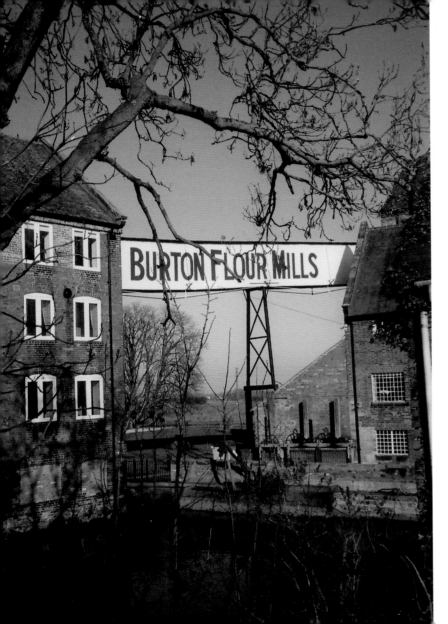

Burton-upon-Trent is 156 miles from Spurn Head. Here the river splits thrice forming, from north to south, Andressey Island, Abbey Island and St Peter's Island.

St Modwen established an abbey here in 1004 and the monks first brewed from an underground spring off the Needwood Hills to the west of the town.

Burton Bridge extends for 1,410 feet, and consists of thirty-two arches. It was rebuilt in 1864, after the previous one was fought over during the Civil War in 1643. It was the only bridge until Lord Burton paid to replace the ferry to Stapenhill with a suspension bridge in 1889. It wasn't a road bridge and it was over another 100 years before the St Peter's Bridge carried the A444 over the Trent into Burton.

Burton-upon-Trent became the smallest non-cathedral town to be granted county borough status in 1901, being superceded by Hanley in 1888 (now city centre of Stoke-on-Trent).

*Right*: Abbey Island is part of the Washlands public open access land in the middle of Burton. It is linked by the Ferry Bridge, with the views from Cherry Orchard downstream to Burton Bridge and the rowing club.

*Below*: An ode to water in 'the washlands'.

St Modwen's Collegiate church is built on the site of Burton abbey. When the Trent and Mersey canal was built in 1770 the town effectively became an island as the canal contours to the west.

Many of the public buildings were sponsored by the Bass family including the square around St Paul's church with the town hall built in the 1880s. Micheal Bass was created Lord Burton by Prime Minister William Gladstone – partly in recognition for his philanthropy in the town.

The famous Bass red triangle was the world's first registered trademark in 1875. They were also the original I.P.A., supplied to British troops in India; it travelled well and was not too high an ABV (alcohol by volume).

Branston and Marmite are brewing related products invented in Burton-upon-Trent. Football fans will know that Pirelli sponsor Burton Albion; Nigel Clough was their manager when they moved from their old ground.

Ferry Bridge was built in 1889 and its 240-foot span makes it the largest suspension bridge in Staffordshire. St Peter's church tower on the east shore is Stapenhill parish church of 1880.

The piers of the new St Peter's Bridge can be seen just beyond the bridge. Built in 1985, it is Burtons only second road crossing.

East Staffordshire District Council, along with the Aggregates' fund, is establishing a recreational route along the Trent from Wychner Bridge as part of the Three River Project linking Birmingham and Nottingham via the Tame Valley. The view of the river here is not unlike the Hammerwich Bridge over the Thames, but less cluttered and peaceful.

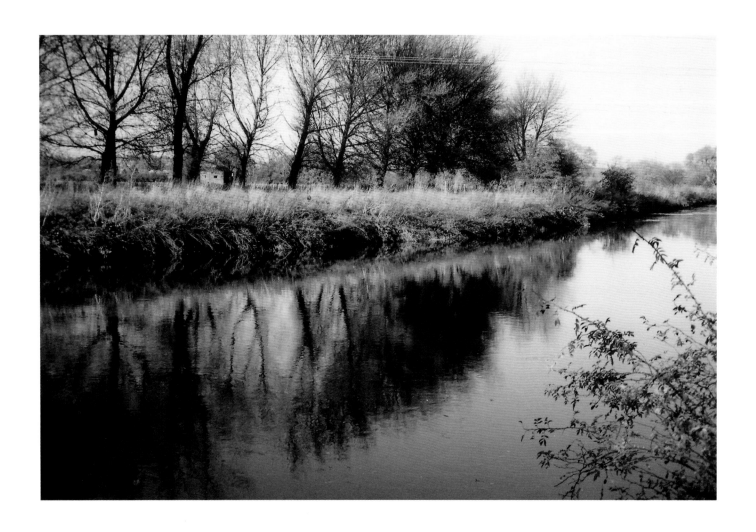

In the ten miles between Burton-upon-Trent there are twelve broad meanders and three large 'holmes' or islands: Fatholme, Borough and Catholme. Evidence of farming going back 5,000 years has been found in this part of the valley.

The river near Walton-on-Trent shows the extent it has cut down into the alluvium by the height of the bank. Close by runs Rykneild Street (A38), a great south-west–north-east route, which was seen as a vital strategic line in the Second World War where 'stop line' defences were constructed. Many pillboxes still survive around the Tame/Trent confluence and nearby Trent and Mersey canal.

At the smaller Mythaholme is the National Memorial Arboretum. Began in 1999, it forms part of the new National Forest, incorporating the former historic Needwood and Charnwood forests. It was greatly depleted of woodland by deforestation, coal mining and quarrying.

One of the 450 memorials to those who served, sadly in too many conflicts since the Second World War. There is only one year since 1946 we have not had a fatality in the Armed Forces. We tend to forget those who die in peacetime, in normal duties of training to defend our nation.

Here at Mythaholme, where the waters of South Staffordshire meet in the River Tame from those of North Staffordshire at a peaceful confluence of the Trent is a suitable place to reflect.

St Leonard's church was founded before 1200 at Wynchnor, and is seen here from the water meadows of Alrewas–Alderwash. Basketmaking was common, no doubt going hand in hand with the eel fishing that used wicker traps in many places on the Trent.

Alrewas Weir and Salmon Leap exist due to a clever piece of engineering by James Brindley, effectively a crossover of the Trent and Mersey canal – the last time river and canal meet and where water from Rudyard lake flows into the Trent. At Fradley Junction, the Coventry canal joins and passes within a mile of the Trent Valley station at Lichfield.

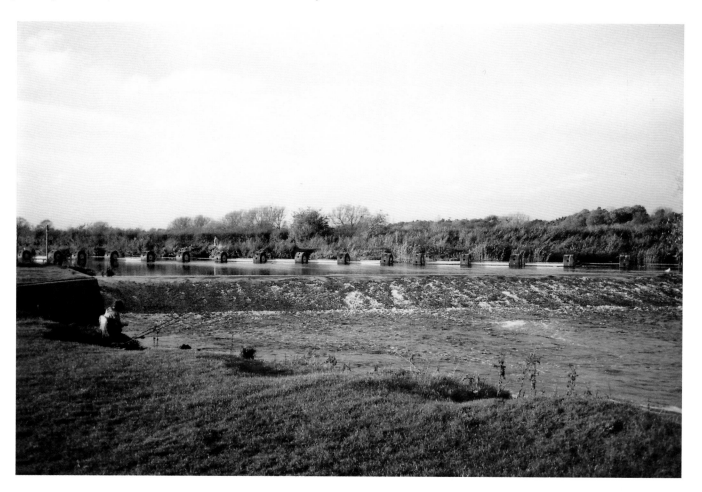

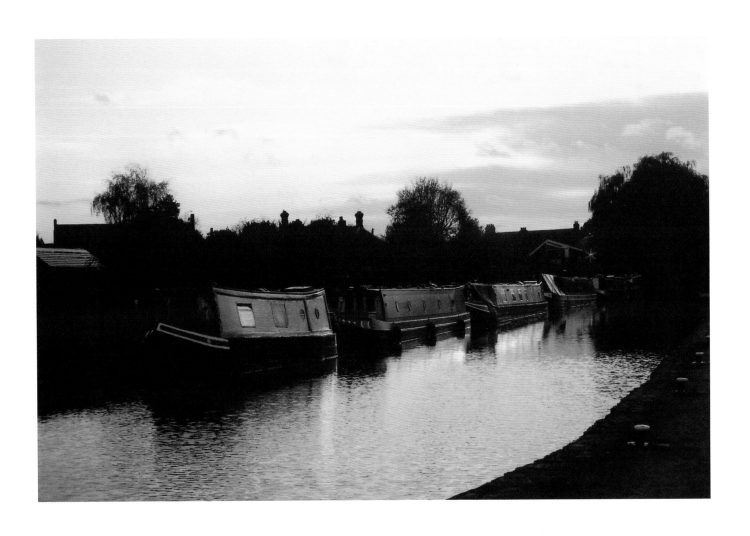

# VALE OF TRENT

The three spires of Lichfield Cathedral are known as the 'Ladies of the Vale' and it is the only triple-spired cathedral in England. It is dedicated to St Chad – Mercia's first bishop (669–72). The site was near to the Roman massacre of Christians, Lichfield.

King Offa (757–96) had Lytch Field made an Archdiocese, covering all lands between the Mersey, Ouse and Thames. The heart of Mercia is on the Upper Trent's main tributary the Tame. Woden established Wednesbury near its source and Offa made Tamworth his capital. Perhaps it is no coincidence that the strategic Walting Street connects the two by its roadside at Hammerwich, which is where the Staffordshire golden hoard was discovered in 2009. This hoard was largest Anglo-Saxon collection of gold, silver and semi-precious items in Britain and is now on display in the Potteries Museum, Stoke-on-Trent.

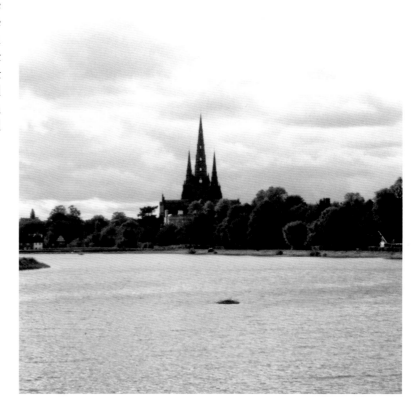

*Facing*: Dusk at Alrewas on the Trent and Mersey – part of the Staffordshire Ring. At Alrewas, at the confluence of the rivers Tame and Mease with the Trent, marks the most southerly point on its long course. Here it makes a huge 90° turn to assume its north-east direction to Burton and Repton into Derbyshire. The former Drakelow power station was on the eastern bank of the river just south of Branston and is now a nature reserve created by the CEGB.

*Left*: Yoxall Bridge is between the mouth of the River Blithe at Nethertown and River Swarbourn at Wychnor. Here the Trent bifurcates forming the island of Saddlesall, north of Kings Bromley.

*Facing*: The three-arch stone bridge remained in use until the 1990s even though it was only one lane wide. The new girder bridge has a single 320-foot span.

King's Bromley accquired the royal subrequet in honour of the Earl of Mercia's granddaughter marrying England's last King in 1060; he was Lady Godiva's husband.

The River Blithe is Staffordshire's fourth longest, rising off Wetley Moor, east of Stoke-on-Trent. Blithfield Water is 6 miles upstream and was built by the South Staffordshire Water Co. in the 1930s. It contains 4,000 million gallons of water and supplies Walsall, Aldridge and West Bromwich.

The shoals on the Bromley arm of the Trent, on to Saddlesall, were fordable by horses and cattle.

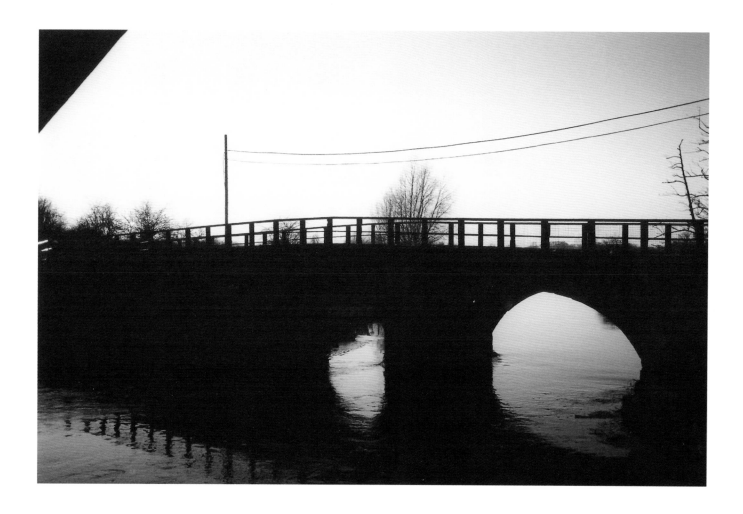

*Above*: King's Bromley, one of the manors of the Earl of Mercia. Here Leofric's granddaughter married King Harold, the last English king (1066).

*Left*: A green lane below Morrey – the place of eels – with Yoxall Bridge in the background.

*Facing*: River Wrack. The strewn timber is witness to the power of the Trent in flood. Much natural woodland has been cleared for gravel extraction in the floodplain. Kings Bromley has acquired a sailing club as a result of grand extraction, but walkers are hindered by lack of a footbridge and are forced onto busy A roads!

High Bridge at Handsacre has a single 140-foot span and was built by the Coalbrookedale Co. of Staffordshire's Abraham Darby in 1830. It has an inidentical twin over the River Tame near its entry to the Trent 188 walked miles from Spurn Head, known as the Chetwynd Bridge.

At the site of an earlier bridge in 1403, the two knights of the manors of Mavesyn and Handsacre found themselves on opposing side of the War of the Roses. Sir Robert Mavesyn killed his rival at the spot and rode with his men to fight at Shrewsbury, only to die with Hotspur in that battle!

Sir Oswald Mosley opened the spectacular High Bridge in 1830. He later became the local MP and was the father of an infamous son, Max Mosley? Upstream is Armitage and Brereton (the frontispiece was taken on Brereton Hill). The gothic Hawkesyard priory, further upstream was built by the Spode family, who many centuries ago came from Clun to Staffordshire to set up a pottery in 1770.

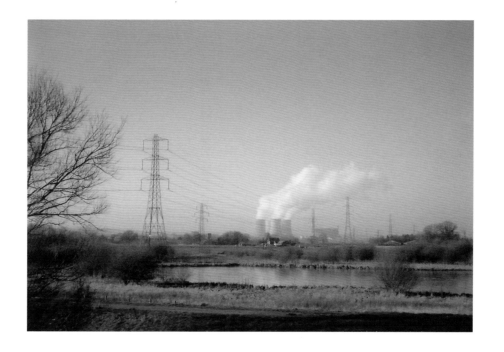

Rugeley is the last working power station in Staffordshire on the Trent; those at Meaford and Drakelow have gone. 40 miles from Trent well and one major tributary remaining! Staffordshire's newest colliery was opened at Lea Hall, adjacent, and fed coal straight into the power stations until 1990.

Rugeley was to benefit from the Trent and Mersey Canal perhaps more than any other rural town apart from Stone – upstream 20 miles. It has managed to retain its Trent Valley Station and now has a reopened town station.

This part of the Trent Valley will not look the same after the HS2 railway is built. It will cut a swathe as wide as the quadruple track already here and sever the vale at Ingestre, ploughing a gough across its parkland to reach the Sow at Meece Valley.

Armitage is known the world over for its bathroom suites, but the river has given up brass spears left by the Romans.

James Brindley built the first canal tunnel on the Trent and Mersey here in 1776. It would take him eleven years to push the Harecastle Tunnel through at the summit, the canal opened in 1777, but sadly its chief engineer had died and missed its completion. He is buried at Newchaple near Mowcop.

*Facing*: Wolseley Bridge, designed by Rennie and built in 1800 to replace a wooden structure. The Wolseley family seat was nearby for centuries. Eleven baronets have held the title, and there are branches in Ireland, Australia, the USA and Herefordshire too. Frederic Wolseley established the first British car company building. Its first vehicle, in 1895, was driven by Herbert Austin who founded his own car company in Birmingham.

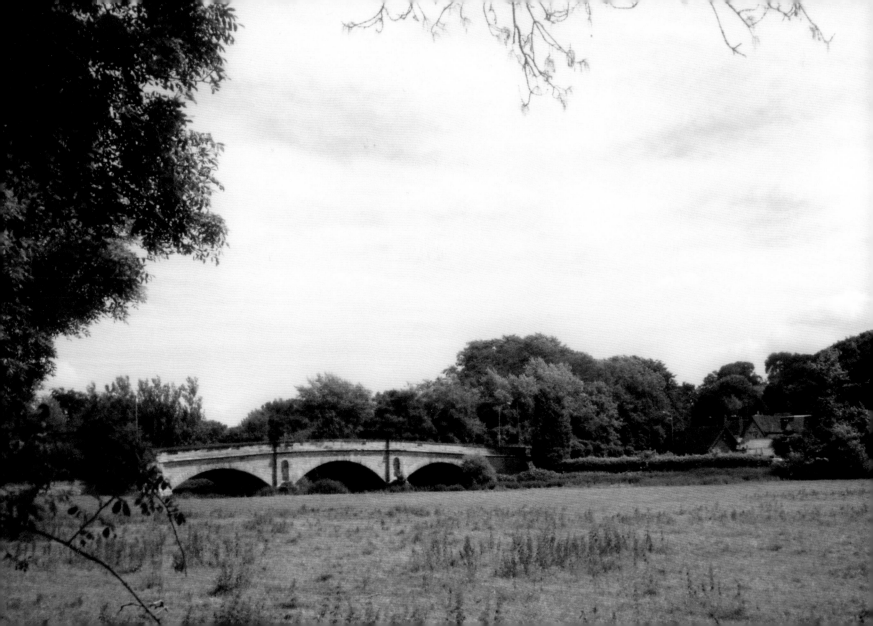

The Trent Valley line, built in 1847, linked the Grand Junction Railway (LNWR) at Stafford and provided a direct line to London. At Colwich Junction the North Staffordshire Railway's line from 'the potteries,' linked to Crewe and Manchester, joins the G.J.R close to the Trent and Morsey canal.

Viscount Anson of Shugborough insisted that any railway from Stafford be either diverted or put into a tunnel. The entrances to the Shugborough Tunnel are as ornate as the other Classical park monuments.

It was Sir Robert Peel MP who cut the first sod at Tamworth on 13 November 1845 for the Trent Valley line. The family seat was at Drayton Basset, which is now Thomas the Tank Engine theme park.

It is a familiar story for the estates of the Earls of Shrewsbury (at Alton Towers) and the Duke of Sutherland at Tentham Park. Only the Earls of Lichfield have escaped such a fate, along with Earl Harrow at Sandon; these are the Earlaries.

It is a familiar story for other estates. Ingestre, the former Earls of Shrewsbury, now an Arts Centre, golf course and self-catering accommodation. Trentham, further north has succumbed to the diversification factor process too. Shugborough Park has been rescued by the National Trust. The former seat of the Earls of Lichfield farmed this northern tip of Cannock Chase and the Vale of Trent. At Chartley, famous for their cattle, the Earls of Essex and Derby had their castle. The only remaining intact estate is that of the Earl of Harrowby at Sandon. Together with the Uxbridge estate at Beaudesert Park and Earl St Vincent at Meaford. That eight Earls –Earlaries!

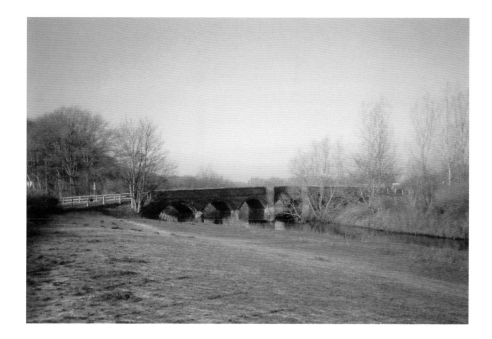

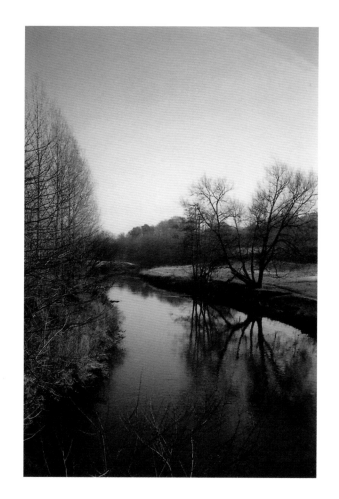

*Above*: Severn Arches spans the Trent at Little Haywood. This bridge, built in 1888 in fine blue brick, replaced an earlier wooden one. The money was raised by public subscription to mark Queen Victoria's Jubilee and was named after the biggest contributor, Mr Joseph Weetman.

*Right*: View downstream from Weetman's Bridge looking towards Wolseley. The A518 Stafford–Tamworth road runs alongside left. This is a very fertile part of the Vale of Trent and had very large estates belonging to six earls. But that's another story too long to be told here.

Shugborough Hall lies between the Rivers Sowe and Trent. It was the ancestral home of the Ansons, Earls of Lichfield, and is now in the care of the National Trust with Staffordshire County Council. A part of the county museum the brewhouse has been reactivated.

Shugborough Hall a fine Palladian mansion built For Thomas Anson, brother of Admiral Viscount George Anson, between 1693–1794. As commander of the naval squadron he was charged with seizing Spanish ships. On the commission of this task, he captained HMS *Centurion*. He circumnavigated the globe, returning with a galleon full of treasure in 1744 for George II. He was given a percentage of the haul as a reward.

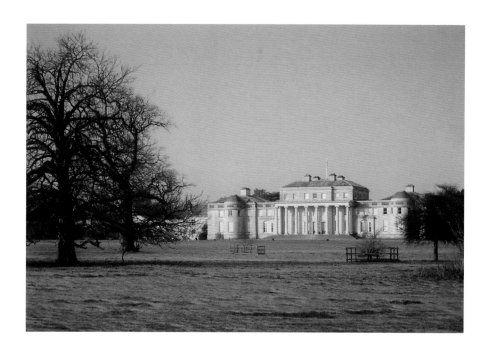

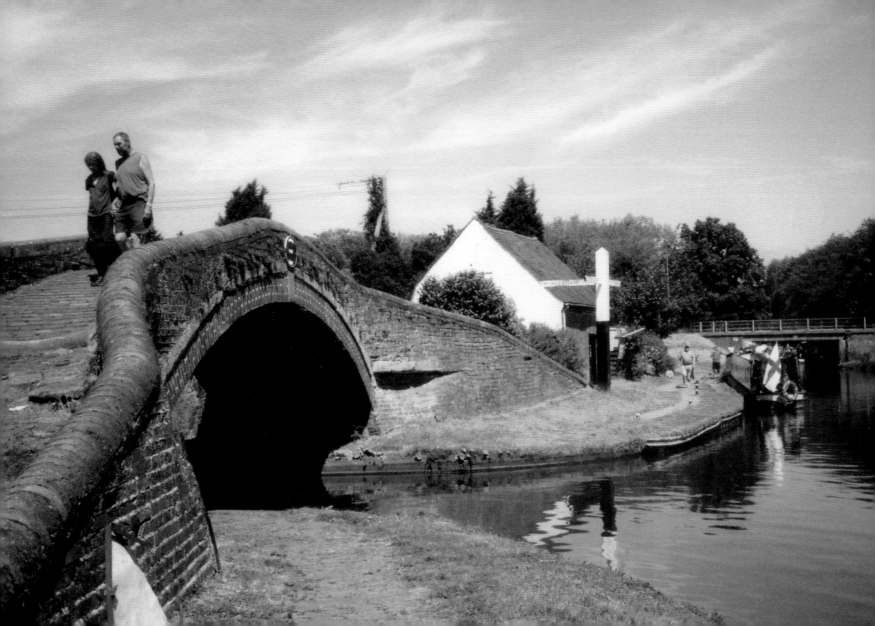

Pea Hill is one of the sandstone bluffs that jut into the valley off Hopton and Salt heaths. Hopton Heath was the scene of a Civil War battle on 16 March 1643. A Royalist force defeated the Parliamentary force attacking Stafford. The Earl of Northampton directed his cavalry to Haywood where half the Roundheads were slain or captured. Sir John Gell and Sir William Breseton had 3,000 men on the heath and were split by a Cavalier charge on the right flank (nearest Stafford). The zealous rout nearly enabled the left flank to win the day. The returning Cavalier cavalry prevented this and although the Royalist leader was killed they had captured 500 men, 300 horses and much ammunition; Stafford was saved from Cromwell's forces for the time being. The Earl of Essex of Chartley Castle was one of their chief commanders.

Hopton Heath serves as part pf RAF Stafford storage, but the site of the battle has an interpretation board can can be reached via the Holy Bush Innn, Salt. The oldest licensed inn in Staffordshire.

It is a rare oddity of geology that at Shirleywich, (a name indicating salt presence), has produced one of only two inland salt marshes in Britain at nearby pasturefields.

*Facing:* The junction of two of Brindley's canals at Great Haywood. The Staffordshire and Worcester Canal joins the Trent and Mersey 53 miles from Trent Lock in Nottinghamshire. The roving brick-built bridge is one of Brindley's unique pieces of architecture.

The Trent edges around the north-eastern corner of the Cannock Chase Area of Outstanding Natural Beauty. (AONB) This upland area has been created by two fault lines converging forming a horst block. Once a larger royal hunting forest, it became a chase and portions were given over to the Bishop of Lichfield and Earl of Essex and Derby. Wild deer roam over the 26 miles$^2$ and can be seen in quieter parts of the chase.

At Great Haywood, on the Chester Road (A51), the milestone declares the distances to Lichfield, Nantwich, London and Chester.

It may be of interest to note, that from here it is a shorter journey to London than it is, even via the Humber Bridge, to Spun Head – 185 miles. It is only 32 to Trent Well, but uphill 750 feet!

Great Heywood was largely built by the Ansons, who removed the village of Shugborough when they had the parkland landscaped by Stuart and Wyatt.

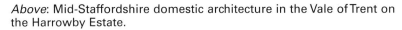

*Above*: Mid-Staffordshire domestic architecture in the Vale of Trent on the Harrowby Estate.

*Right*: The view upstream from the rebuilt County Bridge at Sandon. Pleasingly there are no bank edge wire fences as is all too often the case along our rivers today. These water meads were once frequented by Chartley cattle – an ancient breed of white beasts.

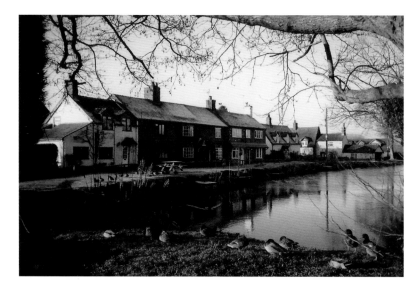

*Left*: Burston's church is dedicated to St Rufin – one of the king's sons put to death for allowing St Chad to convert them to Christianity. These Princes of Mercia were responsible for the founding of a priory (in 670) and the place became known as 'Stone'. King Wulfhere later repented and he became Christian.

*Right*: The peaceful Vale of Trent at Burston. Water meadows, marsh plants and willows form part of a conservation area between Aston-by-Stone and Enson. The image above shows ducks enjoying an ice-free village pond. Burston has a pub worth a visit.

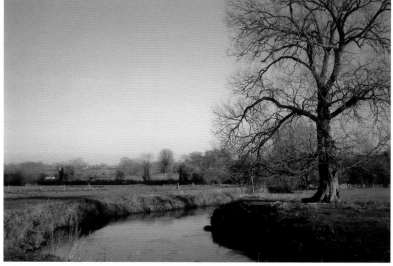

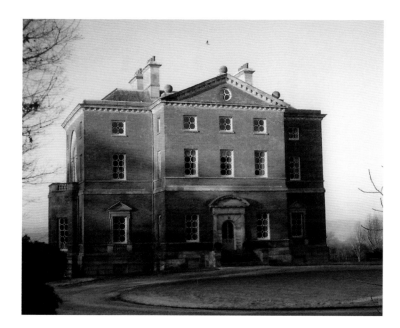

Barlaston Hall, built for Josiah Wedgwood in 1756 by Sir Robert Taylor when the family moved from Etruria Hall. Adjacent is old Barlaston church (1886), built onto a medieval tower.

Due to the extensive coal mining from the largest pit in the south of the city the two buildings were placed under threat of subsidence – the church had to be vacated in the 1980s, but the hall was rescued by the Landmark Trust.

Looking over the Trent Valley to the site of Wulferchester at the end of Tittensor Chase and Hanchurch Hills beyond it must have seemed like heaven after the smoke and grime of the Fowlea Valley at Etruria.

# HEAD OF TRENT –
# TRENTHAM TO BIDDULPH MOOR

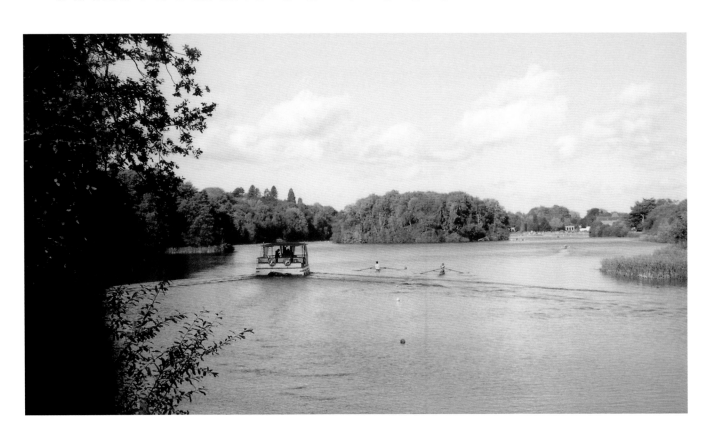

The influence of the Potteries upon the rest of North Staffordshire wasn't just about shaping and firing the pots, which required clay and coal, but refining the ingredients for finer and more elaborate products.

The Moddershall Valley on the scarp slope of the Hilderstone Hills has in its short 6-mile length ten watermills. Originally grinding grain, many were given over to producing flint powder or to ground bone to make fine china.

On one of the other short side streams is the highest waterfall of the Trent headwaters, created by a hard sandstone band which gives rise to Downs Banks and Tittensor Chase. Between the two the Trent has burst through at Meaford. Here, far from any coast, was born another of our greatest admirals, John Jervis. He built Nelson's navy, defeating the Spanish fleet off Cape St Vincent in 1797 and prevented them joining the French fleet to attak the Netherlands. As first sea lord he reformed the dockyards and stamped out corruption. He was created Earl St Vincent and married another admiral's daughter, Admiral Parker, also from Staffordshire.

It was at Meford that the Central Electricity Generating Board chose a site by the river to construct a new power station in 1947. My grandfather worked on the installation of the steam turbines after previously being sites engineer at the ROF Swynnerton, a role he undertook by bicycle from Hanford, completing up to 35 miles some days.

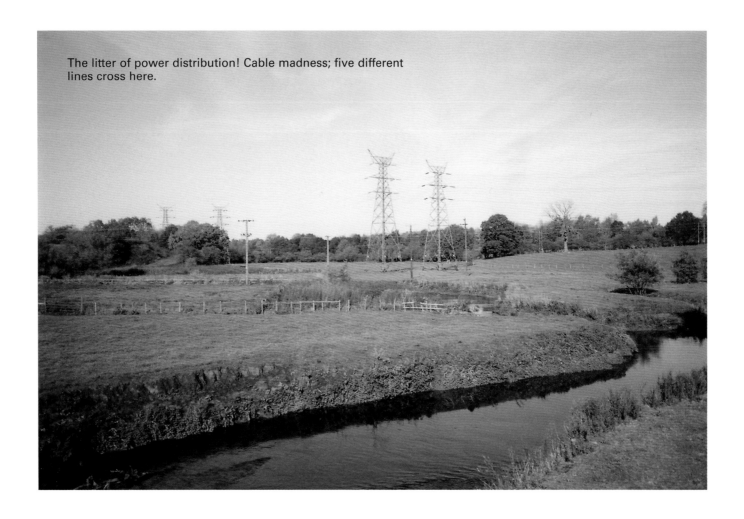

The litter of power distribution! Cable madness; five different lines cross here.

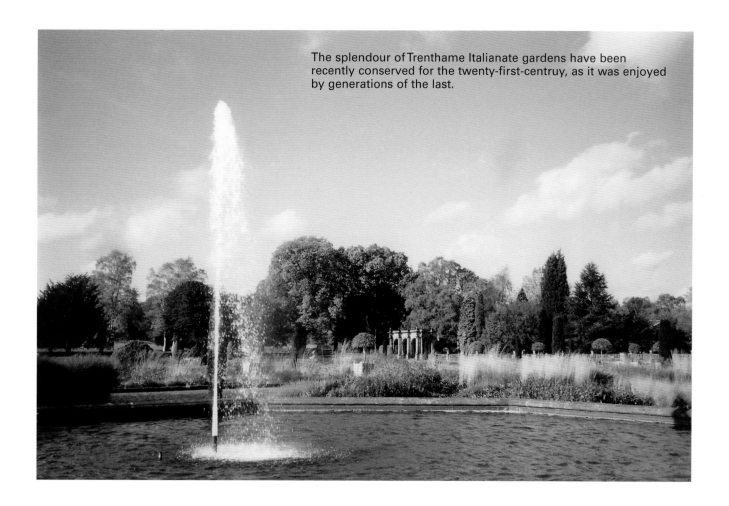

The splendour of Trenthame Italianate gardens have been recently conserved for the twenty-first-centruy, as it was enjoyed by generations of the last.

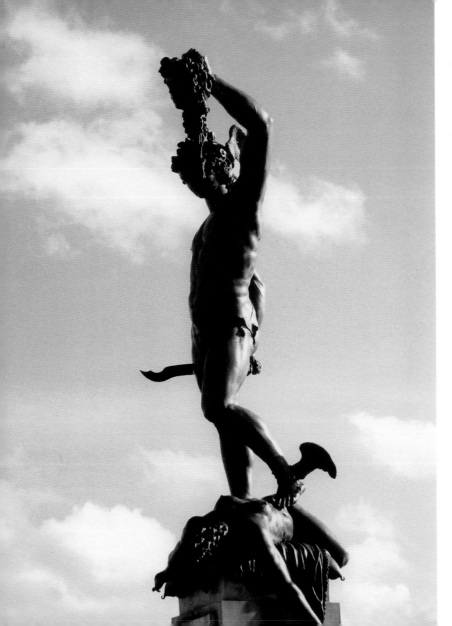

Trentham gives its name to the most southerly suburb of the City of Stoke-on-Trent, but it began with just a priory, founded by King Wulfhere's sister, Werburgh, in 680. It passed into the Leaveson family when the minor monasteries were dissolved by Thomas Cromwell in 1537. By 1777, the park was redesigned and the Marquis of Stafford had the Coalbrokedal Iron Co. build the first cast-iron bridge over the Trent – the second in the world.

The Leveson-Gowers became Dukes of Sutherland and commissioned Sir Charles Bary, architect to the new houses of parliament, to build a palace at Trentham. The gardens were laid out in the Italianate style and the duke had a copy of the famous *Perseus and Medusa* by Cellini made in 1842. It has recently been restored (2014).

The Duchess of Sutherland bequeathed the park to the people of Stoke-on-Trent as a public open space. It is now in the hands of St Modwen plc.

Even after the palace was demolished in 1912 the gardens were very popular, as was its ballroom. People from as far Manchester and Birmingham would travel here as for evening dances. Fortunately the A34 provided a direct link, passing Trentham's front gates.

*Facing*: The oldest oak in the manor. Behind is only remaining part of Sir Charles Barry's Palace and adjacent parish church of All Saints and St Mary, incorporating Norman and early English architecture.

Arboreal delights by the sparkling river. The Marquis of Stafford had the world's second iron bridge built over the Trent here in 1777.

With the departure of the Sutherlands before the First World War, but not their influence (the boroughs of Newcastle-under-Lyme and Longton can testify to that), local and county political leaders were directly or indirectly nominated by the Marquis of Stafford.

The Sutherland Institute was Longton's equivalent of Tunstall's Wedgwood Institute during the Second World War. It was the 'Gardens', as locals always has, and referred to Trentham the ballroom in particular which housed the evacuated Clearing Banks from London. Many locals made spare rooms available to lodgers, including my grandparents at No. 222 Stone Road, Hanford, who had Mr Hindmarsh.

Here at Trentham Gardens the river adventurist Tom Fort gingerly launched his punt into the Trent to guide it the 110 miles to the Cromwell Lock north of Newark. His epic journey was first shown on BBC4 in 2013. The ballroom was occupied by the clearing banks from London and many locals made spare rooms available to lodgers, including 222 Stone Road.

In the park a contingent of the Free French Army was camped; my father had a ride on the back of a tank during a 'meet the locals' day. Part of RAF Stafford's 16-MU had a storeage depot too.

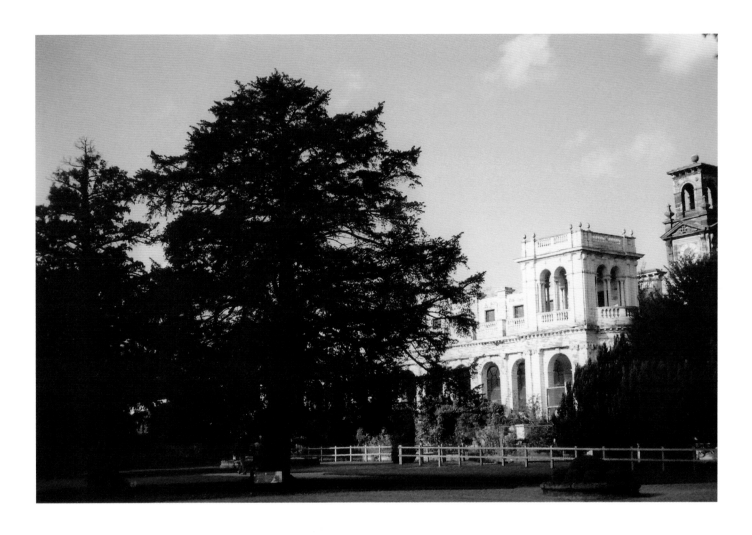

*Above*: The Michelin footbridge, Hanford, crossing the Trent – the only new bridge in Stoke-on-Trent over the river since the 1980s

*Left*: Spring begins by Hanford – the Trent descends gradually and it is joined by the River Lyme. Close by, in 1927, the first Michelin factory in the UK was built. My grandfather moved from Manchester to help install the steam power plant. The factory had its own electricity generating station which fed into the Grid when it had surplus, thus making it the power station closest to its source of any British river.

The oldest surviving bridge over the Trent in the city, incorporated into a recent widened bridge on Abbey Lane, Abbey Hulton. The abbey at Hulton-on-Trent was founded by Cistercian monks in 1219. It had several grange farms locally, such as the one at Stanley on the edge of the Staffordshire moorlands.

My father was born in Abbey Hulton and can recall the archaeological dig in the Trent, which uncovered a log boat similar to the Shardlow boat. It is a pity that despite the prominent blue signs, it is not yet possible to walk by England's biggest river through its first city (not that Stoke-on-Trent is an exception in this matter). North-west Leicestershire is only too proud to announce its presence on the new A50 bridge, but hasn't replaced the one lost at Trentlock. Nottingham has a love/hate relationship too, keeping north bank from south, especially at weirs, unlike similar locations on the Thames! There hasn't been any replacement of any ferry links that allowed much greater access to both banks of the river on foot.

Stoke-on-Trent has slowly begun to appreciate its river, having had it hidden for over 150 years by the pot banks, pits, marl holes, steelworks and engineering works.

Slowly it has begun to open gaps upon the 8 miles that the Trent flows within the city boundary. For the distance, it is check by jowl by the Caldon Canal from Norton Green to Northwood; there is no problem of access. It is where it wanders off on its own through Bucknell, Joiners square and Fenton Manor that difficulties are encountered. Hanford to Trentham has been forgotten completely.

On its journey through the city it collects seven side streams: Stockton Brook, Ford Green Brook, Abbey Brook, Wetley Brook, Fowlea Brook (by far the longest and largest), Longton Brook and Newstead Brook.

Water supply for the 17-mile Caldon Canal was originally from Stanley, Deep Hayes and the Serpentine reservoirs, but heavy traffic caused much loss of water into the main Trent and Mersey.

Ambitions for the future – a path may be, but not yet a Park. The city is taking pride in its river. Abbey Mill Lane, Abbey Hulton.

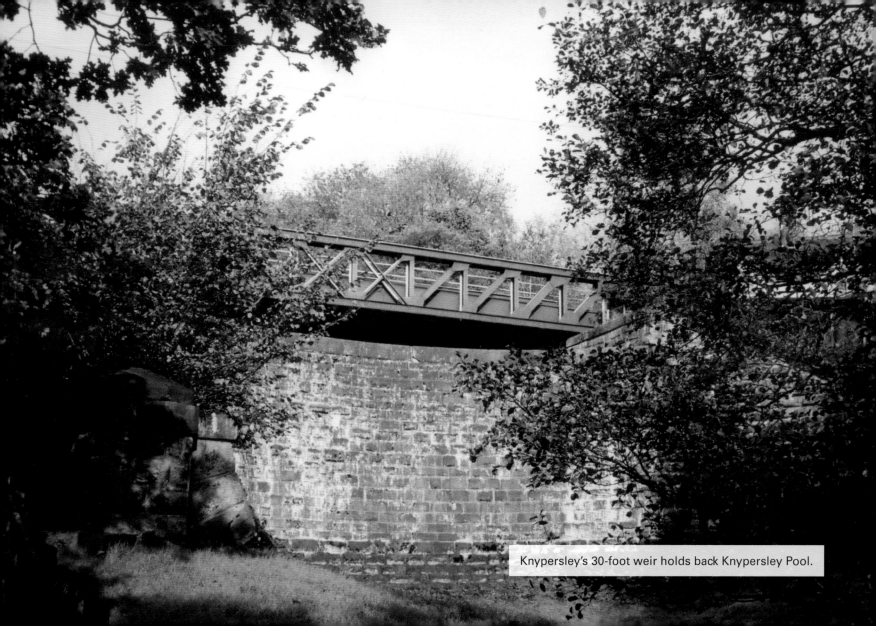

Knypersley's 30-foot weir holds back Knypersley Pool.

View south across the Head of Trent from Knypersley bank.

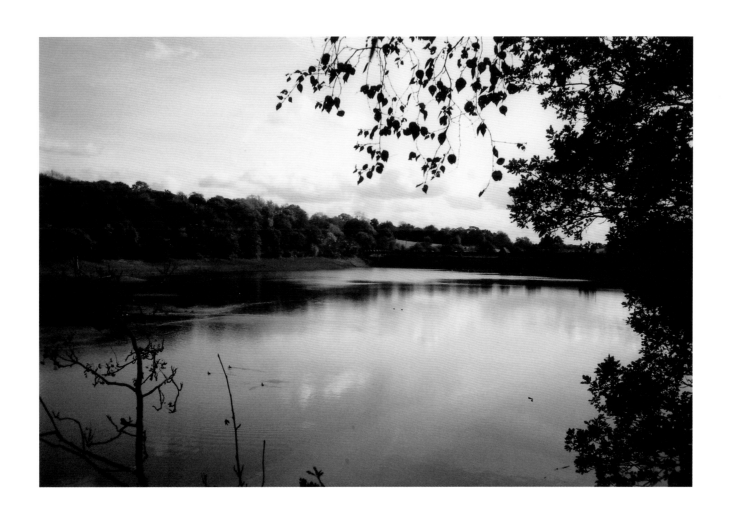

# KNYPERSLEY RESERVOIR

**Knypersley Reservoir supplies between seven and eight million litres of water each day. This water doesn't come out of taps as drinking water, it keeps narrowboats afloat!**

Knypersley Reservoir was built between 1825 and 1827. Together with nearby Rudyard and Stanley Reservoirs, it provides a constant supply of water to the Caldon Canal and then on to the Trent & Mersey Canal at Etruria.

In the early 1780s Greenway Bank's Serpentine Pool was constructed to supply water to the canals, but 40 years later, as traffic on the canals increased, a greater volume of water was needed.

The famous civil engineer, Thomas Telford, and canal engineer, James Potter, surveyed the land between Greenway Bank and Knypersley Hall estates with plans to build a larger reservoir.

With Telford acting as consultant engineer, Potter began work on the dam. Without the help of modern machinery, it took his men five months to hand dig 29 feet (8.8 metres) to reach a solid foundation on which to build the core of the dam. This was made of clay that was 'puddled' (worked) to create a dense, watertight mass. Earth and more clay were banked up against the core to create the dam that we see today.

Although the reservoir was completed in 1827, it wasn't fully operational for a further two years due to leaks and damaged pipes caused by uneven settlement of the clay core.

To make way for the reservoir a watermill was demolished and re-built below the new dam.

During restoration work in 2006, when the water level was lowered, it was possible to see the old mill pond

## Landscape and Leisure

Today the reservoir sits within Greenway Bank Country Park where you can enjoy a stroll around the water's edge or take part in guided walks and events organised by Staffordshire County Council's Countryside Rangers.

You can find out more about the country park, its wildlife and history at the visitor centre located a short distance up the road (open weekends only).

Contact the Rangers on 01782 518200 for more information.

Thomas Telford was appointed supervising engineer to build a new reservoir at Knypersley and extend a branch off the Caldon Canal to Leek in 1802.

To feed the Leek branch Rudyard Lake was connected to it and by way of the Hazelhurst Aqueduct it in turn went into the Trent and Mersey at Eturia. River and canal merge at Alrewas, so by inference Rudyard is the furthest headwater. Rudyard's longest stream rises off Biddulph Common near the Briddlestones. Thus the total length from Spurn Head is 226 miles, making the River Trent the UK's longest. Before the upper Dane was blocked off from the Rudyard Valley it didn't flow north. Telford's canal feeder stream flows into Rudyard Lake.

Knypersley is now part of Greenway Bank Country Park cared for by Staffordshire County Council. The woodland walks are very beautiful in spring. It is a mecca for water fowl and herons regularly perch on the draw-off tower buoys. Unlike its neighbours at Tittlesworth and Rudyard sailing isn't permitted but they are much larger lakes.

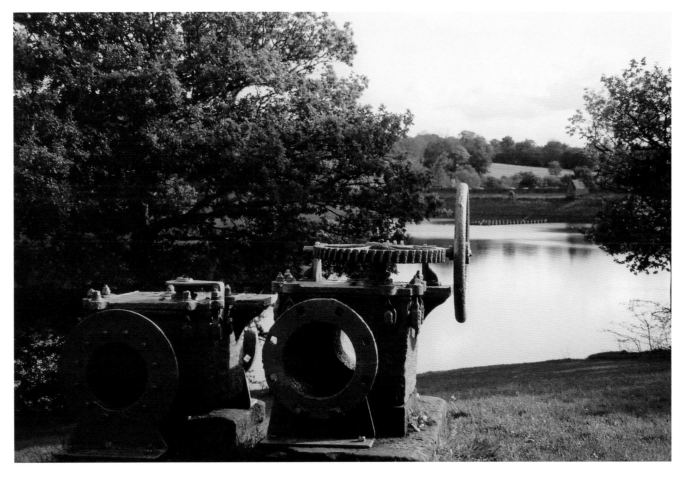

The remains of earlier control house valves by the side of Knypersley Pool. The valve house is located in the centre of the causeway bank (distant right). Herons frequent the filter house barrage, perched like fishermen on the buoys ready for their catch.

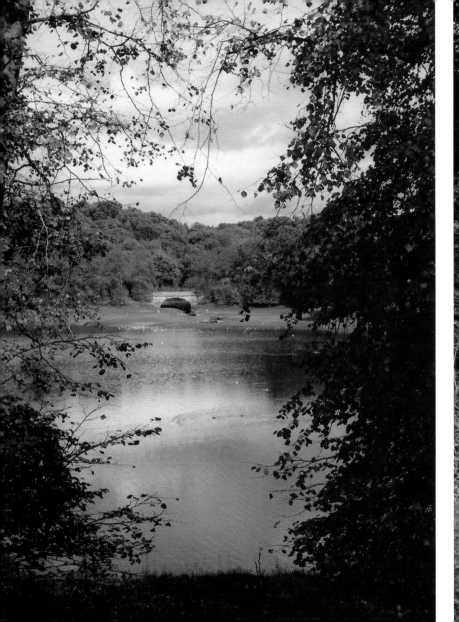
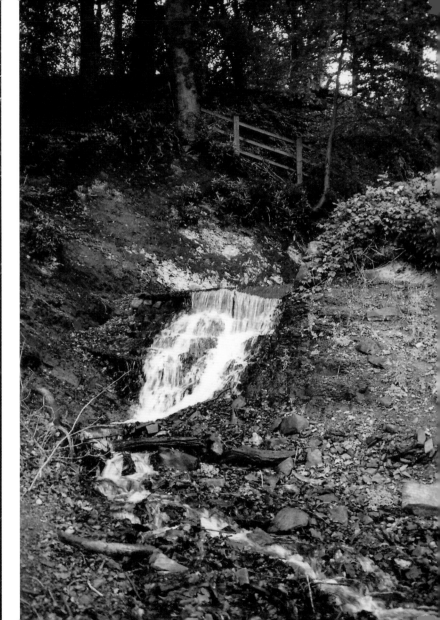

*Facing*: Colwall Bridge across the lake and the woodland of Crowborough beyond the Trent emerges under the bridge having descended 400 feet from Biddulph Moor. Knypersley Pool is part of Greenway Bank County Park. The upper pool, formerly the Serpentine, has a cascade between the two, especially impressive when there is a lowering of the main pool. Staffordshire Moorlands District Council has created several circular walks in the vicinity, one of which is marked from the visitors' centre.

Woodland is rare in the moorlands so the oaks, birches, willows and beeches around Knypersley are a treat as the official source of the Trent is approached – Trent Well.

*Right*: Knypersley Pool is Gawton's Well hidden by the gritstone rocks. The river has cut down through the millstone grit to produce a small gorge – a wooded cleft known as Crowborough.

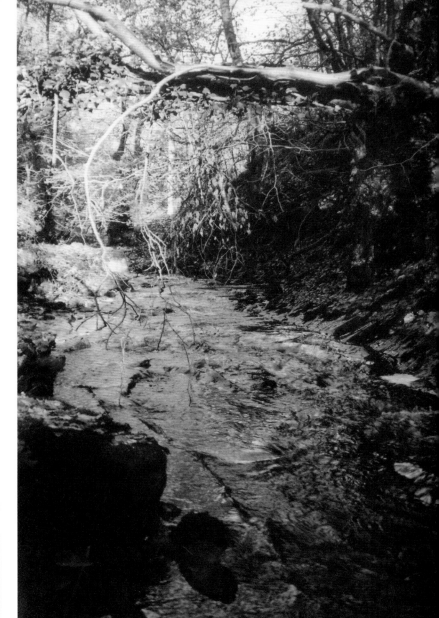

Biddulph Moor has ancient links with the Holy Land. One of the Crusaders' knights, Bertram de Verdun, is said to have brought back stonemasons to work on St Chad's church in Stafford. It seems that after the work was done they sought a remote place to dwell and came to live here upon the moor. It seems bleak on grey days, but they came when Staffordshire had over 75 per cent woodland. Crowborough Wood is the one tangible remnant of such heritage.

Wicken stones form the skyline of the Biddulph Valley, where a stream flows north into the River Dane, so close to the national watershed are we here.

At Biddulph Grange, James Bateman laid out beautiful gardens representing several countries – Egyptian, Chinese, South American – in an imaginative way. He was a friend of Charles Darwin, who was a fellow scientist. The gardens are now looked after by the National Trust and are open to the public.

*Facing*: Upper Trent gorge through Crowborough Wood; over six head streams converge on this point within two miles of the Trent Well.

A splendid mixture of cascades and hardwood spieces such as Oak, Beech, Birch, Rowan and Holly – a very tiny microcosm of Staffordshires lost canspy. In the Moorlands it is only in the steep sided 'V' shaped stream valleys that the remnants of our indigenous woodland can be found. This accounts for Staffordshire having less than 10 per cent of its area as Woodland!

*Right*: Sylvan dell of the wandering invader. In Greek mythology such a place would be associated with a God of the natural world.

Off the East side off Biddulph Common near the pre-historic Briellestones, flows the main tributary into Rudyard Lake.

The outflowing stream goes mainly to the Leek Canal.

This in turn flows into the Caldon Canal bay and the Denford locks, which descends to the Trent and Mersey at Eturra. Canal and River flow together at Alrewas. Therefore the furthest headwater of the River Trent can be said to beat Bridlestones – a further 10 miles!

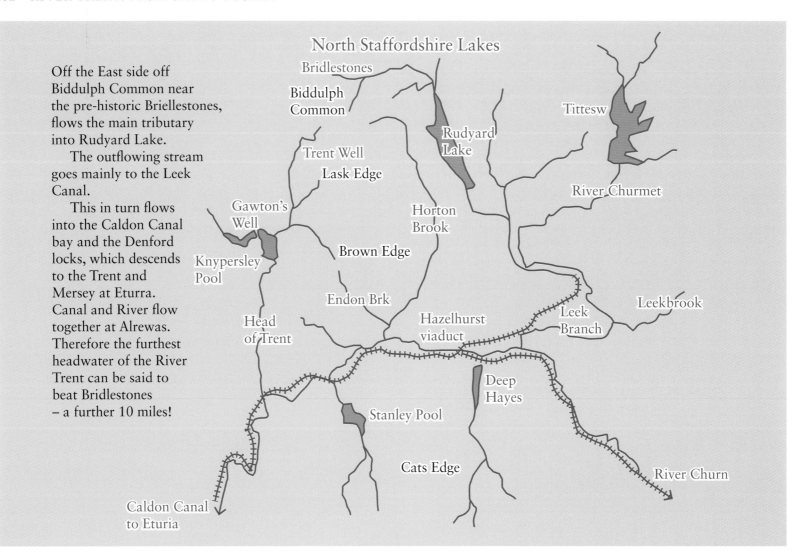

North Staffordshire Lakes

Bridlestones

Biddulph Common

Tittesw

Rudyard Lake

Trent Well

Lask Edge

River Churmet

Gawton's Well

Horton Brook

Knypersley Pool

Brown Edge

Endon Brk

Leekbrook

Leek Branch

Head of Trent

Hazelhurst viaduct

Deep Hayes

Stanley Pool

Cats Edge

River Churn

Caldon Canal to Eturia

Looking across Crowborough Wood and the hidden Trent from Colwall Moor to Mow Cop Castle high upon Congleton Edge. The Staffordshire way starts near Kidsgrove and heads along it to The Cloud near the Bridlestones. Mow Cop was the birthplace of Primitive Methodism *c*. 1807 by local Hugh Bourne.

A band of hard gritstone creates a small waterfall in the Upper Trent 2 miles from Trent Well on the 400-foot descent to Knypersley Pool. The geology changes from the millstone grit to sandstone and coal measures before reaching the New Red Sandstone series of the Bunter pebbles and Keuper marls.

Trent Head Well is on the southern side of the village of Biddulph Moor, which near the end of Lash Edge, a ridge over 1,000 feet lies at the margin of the Peak District National Park.

The masonry dates from 1935 and was placed by Biddulph Urban District Council. There is a higher stream sourced from a spring which disappears for a short distance and it is probably due to its lack of continuity that the 'official' well was chosen for its regularity and accessibility. But as to the highest source of water to flow into the Trent, that could well be from Three Shires Head, off Axe Edge Moor.

In his researches Phil Calyton – *Headwaters – A Great Divide* – He notes that Well Head Farm at 1,030, North East of BUDC Trent Head Well is highest headstream off Biddulph Moor.

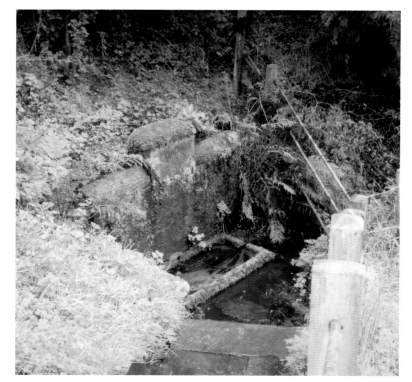

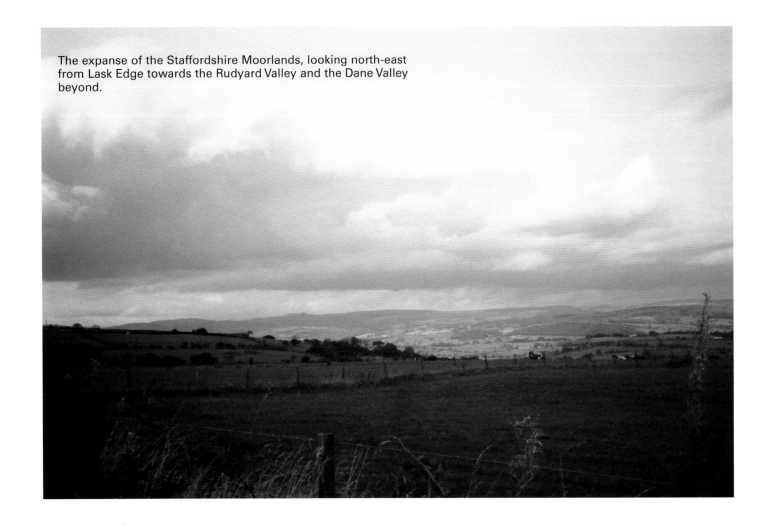

The expanse of the Staffordshire Moorlands, looking north-east from Lask Edge towards the Rudyard Valley and the Dane Valley beyond.

# AFTERWORD

While researching the North Staffordshire canals and the engineer James Brindley, who began as a millwright, and the later improvements to the supply of water to the Caldon and Trent and Mersey canal, it was interesting to look at the flow directions of the system.

The building of Rudyard Lake, which feeds directly into the Leek Branch and not exclusively into the Caldon (to Froghall) or the Churnet, not only took the local streams that flowed into the valley, it also had a leat draw off water from the Upper Dane. Thus it can be said that it is the furthest source of water into the Trent. It is an ironic twist that the River Dane, rising near Three Shires Head, is a tributary of the Mersey. From the source of the Dane off the north-side of Axe Edge Moor to Rushton Spencer it is another 10 miles, thus making the Trent the longest British river at 236 miles. This has been so for nearly 200 years and is very much part of the landscape.

Let me live harmlessly, and neat the brink of Trent (or Avon) have a dwelling – place;

Where I may see my quill, or cork, down sink,

With eager bite of perch, or bleak or dace;

And on the world and my creater think:

Whilst some men strive ill-gotten goods t'embrace;

And others spend their time in base excess of wine,

Or worse, in war and wantonness.

Sir Henry Wotton – Izaak Walton – *The Compleat Angle*r

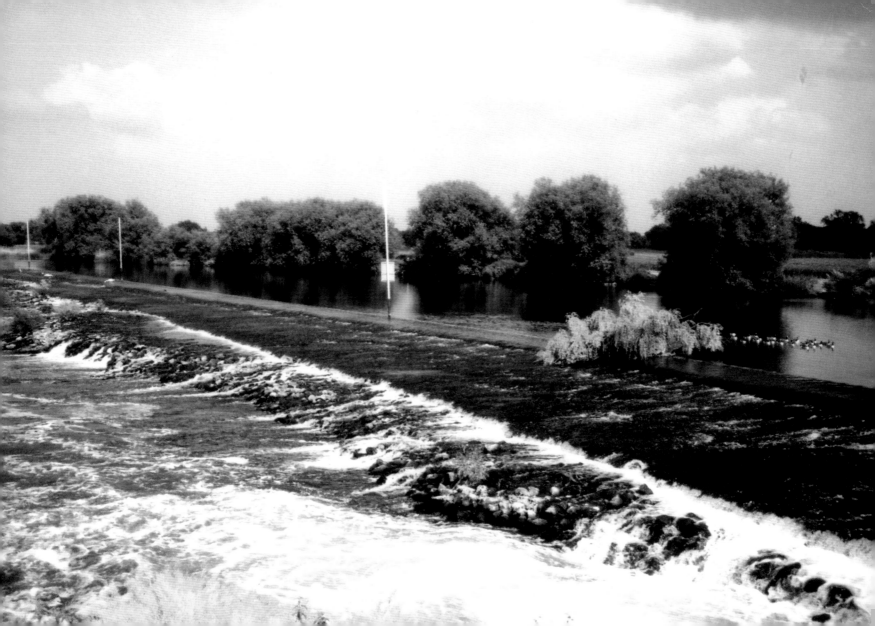

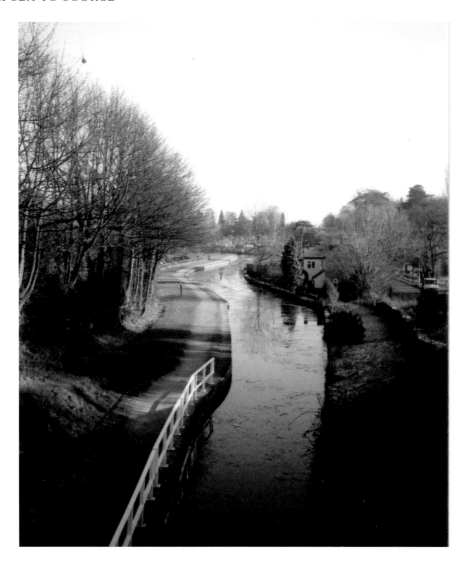